VOICES OF AMERICA

Italian-American Women
of Chicagoland

The Italian Woman......

She's somebody's wife, mother, daughter, grandmother, aunt or niece. She's the backbone of the Italian family. Without her there's no tradition or culture. She keeps the "familia" at the center.

Our Italian American Women's Club was formed so that the culture and heritage of our families could be kept alive. Through conversation, Italian food, stories, family heirlooms etc. we are able to discuss what a wonderful heritage we were given through our ancestry.

VOICES OF AMERICA

Italian-American Women of Chicagoland

Italian-American Women's Club

ARCADIA

ISBN 0-7385-2049-7

Published by Arcadia Publishing,
an imprint of Tempus Publishing, Inc.
3047 N. Lincoln Ave., Suite 410
Chicago, IL 60657

Printed in Great Britain.

Library of Congress Catalog Card Number: 2002112510

For all general information contact Arcadia Publishing at:
Telephone 843-853-2070
Fax 843-853-0044
E-Mail sales@arcadiapublishing.com

For customer service and orders:
Toll-Free 1-888-313-2665

Visit us on the internet at http://www.arcadiapublishing.com

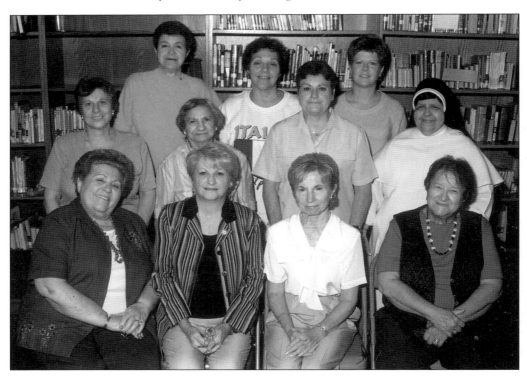

Pictured, from left to right, are: (first row) LaVerne DePaul White, Lorelei Naponello Cartolano, Mary Lou Apicella Gorka, and MaryJo Doody; (second row) Annette Stella Dixon, Rose Frapasella Stella, MaryLou Farino Harker, and Sister Mary Ventura; (third Row) Virginia F. Seriani Cook, MaryAnn Caporale, and Francine Lanzillotti Lazzara. Not pictured are Gaetano DiMiele, Barbara Pyne, and Helen Fry.

Contents

Acknowledgments

The Italian-American Women's Club would like to thank the following people who contributed and assisted in the preparation of this book:

ANN SMITH who courageously tackled the typing.

JEN HABERKORN for her contribution to the book jacket and typing of the Frances Cabrini biography.

MICHEL MARIE ROSE, ESQ., Intellectual Property Attorney, for sharing her expertise and time.

BARRY MCINERNEY and **GEORGE SCHICK**, photographers, for their contribution to the photos used in our book.

Thanks also to all the members of the I.A.W. Club who had the vision to believe in the value of the book, thought it would never happen, and were thrilled when it was completed.

Introduction

In September of 1998, Annette Dixon and Sr. Mary Ventura O.P. discussed the possibility of starting a club whose members would be Italian-American women.

They saw this group as a means of preserving their culture and making known the valuable contributions made by Italian-American women past and present. During the first year they invited interested women from the South Side of Chicago and nearby suburbs. Fourteen members came from Oak Lawn, Evergreen Park, New Lenox, and Chicago. Meetings were held on the second Tuesday of each month at the Oak Lawn Library, and the focus was women from Italy and Italian-American women who were successful in spite of difficult odds.

From 1999 to the present the club has added a few new members; our most recent member is from Joliet. Our meetings were often enriched by guest speakers, such as Anthony Sorrentino, retired director of Joint Civic Committee of Italian Americans, Dominic Candeloro, author from Chicago Heights, and Gloria Majewski, MWR Commissioner.

Members researched our heritage, and the realization was made that there was more that could be done to make it better known. The study of Italian was helpful and the more fluent speakers in our group were of great help. However, the decision was to really preserve and share our rich Italian experiences, and it was through writing this book that the club could accomplish this. A publisher who believed in our project as much as we did was found and a new world opened to us. Our women's club had an opportunity to share our stories and give future generations the benefit of our understanding and passion for the Italian-American women's contribution to America. Our hope is that our stories may inspire anyone who wishes to be better informed about our heritage and culture.

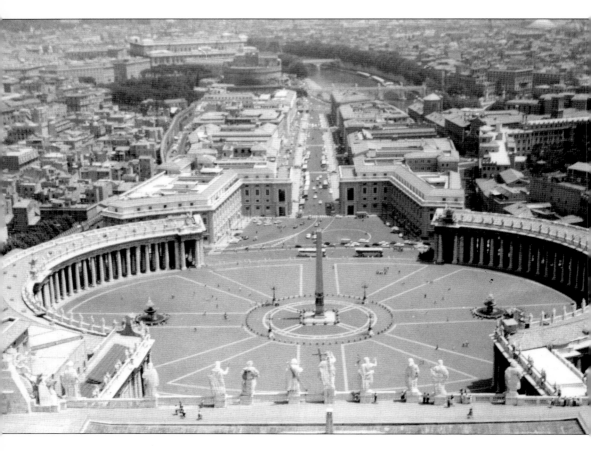

This aerial view of Rome captures some of the city's history and grandeur.

Lessons From the Past

Maria Gaetana Agnesi

Since September 1998, the Italian American Women's Club has met once each month with the goal of acquainting Italian-American women with the accomplishments of their ancestors and bringing to light the contributions Italian women have made to the United States. The members hope that by learning about influential Italian-American women and sharing what they learn, they can eradicate stereotypes against Italian women. Members focus on today's Italian-American women and their past and present accomplishments and publicize their goals in the media. All members are of Italian ancestry.

The first Italian-American woman that members learned about was Maria Gaetana Agnesi. Agnesi was born in 1718 when many European countries were opposed to the higher education of girls. Women were denied the benefits of reading and writing because they were believed to be a source of sin. Thus, nunneries provided the only hope of education for girls.

However, highly educated people came to Italy after the fall of Constantinople, precipitating the Renaissance and changes in education. Still, it was a slow and tedious path to equality in education. The one exception, however, was Italy.

Italy, the birthplace of the Renaissance, had already been influenced by women in the academic arena. Women were looked up to by men for their intelligence. Thus, Italian women were able to participate in the art and academic worlds. Agnesi made her mark in the arena of mathematics during the 18th century.

Agnesi was the oldest of 21 children. She was born in Milan on May 16, 1718. Her family was wealthy and well-educated. Her father was a professor of mathematics. Early in her life, she was identified as a child prodigy. She spoke Latin, Greek, Hebrew, and other languages. During her teenage years, Agnesi had mastered mathematics.

She participated in group discussions on different aspects of the academic world until her mother's death. At that time, she took over control of the household. However, she did not give up her study of mathematics entirely. She published "Propositiones Philosophicae," a collection of essays on science and philosophy, in 1738. In many of the essays, she wrote about her belief in education for women.

Agnesi also began working on her most-important work, *Analytical Institutions*, which

explored differential and integral calculus. According to author Elif Unlu, "When her work was published in 1748, it caused a sensation in the academic world. It was one of the first and most complete works on finite and infinitesimal analysis." The book combined the accomplishments of many other mathematicians with her own thoughts. The book was clear enough to be widely translated and used as a learning text.

Agnesi is widely credited with the curve known as the "Witch of Agnesi." She wrote the equation of the curve as she found the x-axis to be vertical and the y-axis to be horizontal. Today, the opposite is the accepted truth, so the Cartesian equation is used.

The success of *Analytical Institutions* prompted Agnesi's election into the Bologna Academy of Sciences. She was sent a diploma and was named a member of the faculty. While it is unknown whether or not she accepted the position, it is widely believed that she did accept, and served until her father's death. Apparently, Agnesi's father was her inspiration for her interest in mathematics.

Agnesi was also interested in religion. After she gave up mathematics, she spent the rest of her life devoted to the poor, homeless, and sick—especially women. Agnesi was appointed the director of the Pio Instituto Triulzo, a home for the seriously ill, when it opened. She cared for gravely ill women until she died.

MARIA MONTESSORI

Maria Montessori arrived in America for a visit at the end of 1913. She was one of the most famous women in the world, yet when she died in 1952, many who read her obituary either had no idea who she was or were surprised to discover that she had remained active in the post war years. A decade following her death, half a century after her triumphant first visit to the U.S., Montessori was rediscovered and thousands of schools viewed her educational theory and practice as a way to bring enlightenment and individuality to students.

Maria Montessori was born in the town of Chiaravalle in the Italian province of Ancona on August 31, 1870. Maria was an extraordinary child. Reportedly, she would clean floor tiles in a systematic manner and took a great deal of pride in her work. Later, this became known as an "exercise of practical life" in the Montessori School. Also early in her childhood, Maria took an active role as peacemaker between her parents. While the Montessori's were arguing, Maria would drag a chair to them, climb up, and clasp their hands into hers. Some believed this instinctive motion meant "reconciling the family."

A very intellectual young person, Maria enrolled in the University of Rome in the fall of 1890 as a student of physics, mathematics, and natural sciences. She also began her four year course load in anatomy, pathology, and clinical work. She followed this with two years of premedical scientific study which led to a medical degree. Her work, a paper entitled "The Significance of Crystals of Leyden in Bronchial Asthma" was published in a scientific journal.

Maria Montessori also acquired an international reputation as a leading educator. She was a teacher of cultural anthropology for many years at the University of Rome. She received a medical degree and had the distinction of being one of the first woman physicians in Italy. Through her own original thinking Montessori became a leading psychologist, and was a pioneer of progressive education in the 20th century. The "Montessori Method" has become synonymous with the type of education that had its first advocate in Vittorino da Feltre in the 15th century: an education in which the primary concern is the

development of the individual human personality.

Maria Montessori, a single woman, had a son. Though this was not mentioned in public forum, by age 15 Mario Montessori began to live with his mother. He escorted her to various countries and even translated for his mother while studying in India. During WWII, as Italians were being interned in the British Isles and American Colonies, Mario was held in India. Maria waited for her son to be released. He was released on her 70th birthday, a present from the Viceroy of India.

Maria Montessori achieved remarkable results educating many who were generally thought to be educationally hopeless. Her "Montessori Method" stressed the development of a child's initiative by allowing more freedom of action. The teacher acts as a guide rather than a director. She traveled and lectured widely, gaining international recognition and renown. Montessori principles form the backbone for many American pre-schools and Montessori Schools are still a popular school option.

On May 6, 1952, a few months before her 82nd birthday, Maria Montessori succumbed to what was known as a cerebral hemorrhage in the Dutch town of Noordwijk aan Zee, located on the coast of the North Sea, near The Hague. Her son was at her side, and it was there that Maria's last will and testament was written. She left her son all of her material and spiritual possessions and entrusted him with the task of continuing the work she had begun "for the good of mankind." She was buried in a little Roman Catholic cemetery at Noordwijk. Unable to acknowledge him publicly during her lifetime, she finally was able to do so in her last will and testament.

FRANCES XAVIER CABRINI
1850-1917

St. Frances-Xavier (Maria Francesca) Cabrini was born on July 15th, 1850, in the old Lombard town of Santangelo. Her parents were Agostino and Stella. Stella was 52 at the time of Maria's birth. They had lost nine children to death and only Rosa, Maddalena, and Giovanni were alive when Maria was born.

Although a delicate, shy child, she was very intelligent, hard working, and obedient. She had an iron will and was precociously devout, given to prayer, and enthusiastic for foreign missions, particularly in China, from a very early age. This inclination needs stressing in view of her later career, for until ordered by Leo XIII to labor elsewhere, her life's resolve was to enter a religious institution in the Far East. She was educated by the Daughters of the Sacred Heart and, being destined for the teaching profession, obtained the certificates required by the government; but her earlier life seemed a series of frustrations.

Soon after qualifying to teach, she lost both of her parents within a year. At the request of the priest of a neighboring town, she taught successfully in the local school. Aside from doing fine apostolic work, she felt that she was wasting time vocationally. She applied for admission to the Daughters of the Sacred Heart and the Sisters of Cannossa, who were dedicated to missions in Asia. To her dismay, both superiors rejected her on the grounds of insufficient health.

Very unwillingly, but in obedience to her Ordinary, the Bishop of Lodi, she accepted a position of Superior for a small orphanage known as the House of Providence at Codogno, which had been badly mismanaged by three woman who had been running the house. Six miserable years followed until, in 1880, realizing the hopelessness of the task, the bishop addressed Sister Cabrini: "You want to be a missionary. I know no institute of missionary

sisters, so found yourself one."

Frances quietly consented, and with some half-dozen girls from the former orphanage, she founded the Missionary Sisters of the Sacred Heart. They began in a small former Franciscan friary, with orphans from the House of Providence and very little means. However, heroic trust in God was Mother Cabrini's greatest characteristic, and to that end, she lived up to the motto chosen for her congregation: "I can do all things in Him who strengtheneth me" (Philippians 4:13). The episcopal approval was received on December 29, 1880, and it was said that the institute "never knew infancy."

Foundations followed quickly in Milan and elsewhere in northern Italy and finally a house in Rome, although opposition and disapproval from the Cardinal Vicar and others had to first be overcome. That foundation led to the complete re-orientation of Frances' career and the sacrifice of her life's longing. In 1888, she secured the decree of papal approbation of the congregation. At that period, the pope, most of the clergy, and, it might be added, very serious-minded Italians, were deeply concerned over the mass immigration of millions of their poor, illiterate countrymen to the Americas, the result of which threatened to be socially and religiously catastrophic. Ignorant of the real conditions overseas, unable to speak a word of any language but their own, the emigrants were in the hands of agencies whose sole objective was to exploit them. The repayment of the passage money advanced by relatives and friends in America was far more merciful than by agencies. The Italian Government made no attempt to help them on their arrival, to see that they settled down satisfactorily, or to care for them in any way. Disliked by most Americans, not excepting many of their fellow Catholics, they lived crowded into the 'Little Italies' of the great cities under lamentable moral and material conditions. The death rate was high, while to crown all, the notorious Cahensly agitation began in 1886, causing suspicions that foreign intrigue lay behind this dumping of poverty stricken aliens on American soil.

The bishop of Piacenza, Monsignor Scalabrini, aided by other zealous clergy, determined to devote himself to solving the problem. They founded the Society of Saint Charles in New York to care for the emigrants, but Italian Sisters were desperately needed. In 1887, while in Rome, the bishop proposed that Mother Cabrini should undertake the work. She obeyed and boarded at the port of LeHavre on March 23, 1889. Of the 1,300 passengers on ship, Francesca addressed the 700 Italians in their native language. A group of men wanted her to address the issue on the ship. One of them, a Sicilian, informed her that his brother, Guiseppe, was a priest. "I am from Caccamo, Sicily, a village that existed before our Lord came to earth. I was a member of the municipal council and had a cobbler shop. People were going barefoot because of poverty. I couldn't stand that poverty and came to America thanks to a friend."

After having twice invited her and informing her that an orphanage, school, and convent were being prepared, the archbishop, a well-meaning but changeable man, told her, when she arrived in New York in March 1889, that the plans had fallen through, and advised her and her companions to return to Italy. He has disagreed with the temporal foundress and withdrawn his permission. However, Mother Cabrini reconciled the parties and the foundation was made, to be followed by a chain of others, spanning the continent from New York to California.

Besides schools of all grades and charitable institutions of all kinds, she founded four hospitals, with nurses' homes attached to each, one in New York, one in Seattle and two in Chicago. She readily admitted non-Catholics who were willing to keep the rules to these homes, as well as to her schools. Houses were also opened in Central America, Argentina, Brazil, France, Spain, and England, besides several more in Italy. Leo XIII supported the

foundress unfailingly, as did his successors. All did not always go smoothly, by any means. She had to face opposition from clergy and laity. Parties formed against her; two revolutions destroyed her Central American convents; two lawsuits imperiled her work in Italy. Yet she persevered undismayed. Money came in as she needed it; Catholics and non-Catholics were generous. And when all failed, God seemingly worked miracles.

Side by side with business capacities that inspired unstinting admiration, a practical knowledge of building and of hospital and school organization which amazed experts, she had the simplicity and devotion of the most pious of nuns. When negotiating for the purchase of a large property in Chicago, she suspected she was being defrauded, so she sent two Sisters to measure the property with an ordinary tape-measure, to the decided suspicion of the police. Having set her heart upon acquiring a fine college, which was not for sale, in order to turn it into an orphanage, she persuaded the owner to sell to her; we know not how. When seeking to buy a derelict hotel in Seattle for a hospital, and finding it belonged to someone named Clark, she simply ordered the Superior of New York to ring up every person of that name—there were over a hundred in the telephone directory—until she found him.

Spiritually, her life is an interesting study in development. She is an encouraging saint. She was very able, and there was "no fooling Mother Cabrini" according to one who tried the strict disciplinarian; she could have been an autocrat. Owing to want of experience, she was at first narrow in some respects. She had never received normal novitiate training and had to learn by experience. She knew nothing of foreign, especially non-Catholic, countries and she could be tactless.

But grace perfected nature. She had faith; she was a woman of prayer, and she was humble. She was ready to learn to recognize her faults and to work at them. She became noted for her gentleness, and was loved and revered. Her character mellowed, and her great gifts had full play. As time went on, her wide-mindedness was remarkable. She was ready to minister to the criminals in Sing Sing prison and she would work among the most abandoned souls. She became a saint. In 1909, she set the seal, as it were, by giving of herself entirely to her vocation, which had been God's choice and not her own. She became an American citizen in Seattle.

She died in Chicago on December 22, 1917, which remains her feast day. On August 6, 1938, she was beautified by Pius XI, and on July 7, 1946 canonized by Pius XII. On September 8, 1950, the latter declared her "Heavenly Patroness of all Emigrants" (in these days "and of Displaced persons" is often added) and described her as "an extraordinary woman… whose courage and ability were like a shining light."

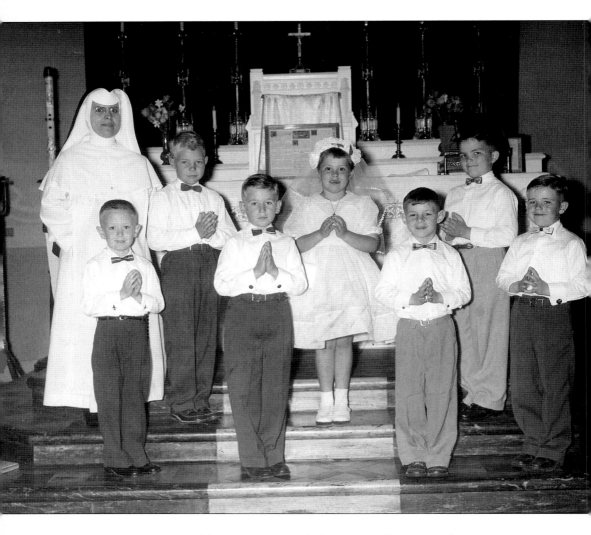

Sister Mary Ventura is pictured here with young Catholics receiving their First Holy Communion at St. Joseph Church in Mount Sterling, Illinois.

Sister Mary Ventura

My father, Philip Ventura, was born in Caccamo, Provincia Palermo, in Sicily in the year 1894. His parents Santo and Peppina Mendola were farmers and lived in the shadow of the Lord's castle. They were able to raise enough produce to feed their family, which consisted of Philip, Santo, Marietta, and a boy they adopted. They were poor but managed to hold their family together.

When Philip was seven years old, his father died and he became a laborer on the neighboring farm. He was more like an indentured servant and was often hungry and tired. He couldn't even take off his shoes at night since the "Master" might call and he had to be dressed and ready. He lived this life for the next eight years and helped provide for his mother and sister.

When Philip was 16 years old and there didn't seem to be any hope of a better life, he decided to join the thousands of male Italians who escaped to America. He boarded a ship and made the two month trip in steerage. Food and water were scarce and the air putrid. If he hadn't been in good health, he wouldn't have survived the trip.

Once in America, things began to improve. Philip worked in a steel mill, saved his money and was able to send some to Sicily. His inability to speak English wasn't an obstacle and he became a successful grocer and continued in this work until his death.

My uncle, Joe Ciaccio, came to the U.S. and joined the army. During WWI, he served in France and was there in 1918 when the Armistice was signed. Since the war was over, he asked if he could go to Sicily and visit his family. Not only did they allow him to go, but since he was in uniform, the entire trip was free.

Uncle Joe visited his family and married Rose Peri. Then he brought his bride and his sister Josephine Ciaccio back to America with him. They settled in Chicago Heights and Uncle Joe introduced Josephine to Philip Ventura.

On April 18, 1920 my mom and dad were married at St. Rocco church in Chicago Heights. After a brief stay among the Italians who had settled in Chicago Heights, they decided to pursue their dream of owning a home and land and starting a family. Their move to Bradley, Illinois proved to be very successful. They purchased a home and built a room in the front of the house to use as a grocery store. This was quite an undertaking since neither of them spoke much English. They must have been quick learners because they soon purchased a store a few miles away in Kankakee. Now my mom and my dad each

had a store and they worked hard and saved the money they earned so they could provide for their family.

Their first child was a son, Santo, named after my dad's father. He died at the age of one and a half of diphtheria. Then in 1926, Josephine was born, followed by me, Mary, and then Frances. With a family to care for, my mother was unable to work, so they sold the store in Kankakee and concentrated on the Bradley business.

Bradley was a wonderful place to raise a family. It was not heavily settled and was surrounded by farmland. Our house had two lots on each side and a big back yard. We were able to have the typical Italian garden and mini-orchard.

Our orchard had a peach tree that produced delicious, freestone peaches. We also had a vineyard of concord grapes, a fig tree, and many cherry trees. My fondest memories are of climbing one of the trees and sitting on a branch eating its delicious fruit. We were also blessed with a field of raspberry bushes behind our property. Raspberries are still my favorite fruit.

Our gardens were a delight to see, planted with every imaginable plant. We had tomatoes, beans, lettuce, and corn. Sometimes we had carrots, cabbage, Swiss chard, celery, and green peppers. We even had asparagus that seemed to grow as fast as you could cut it. Fennel also grew there and we used the seeds when we made Italian sausage.

The 1930s were hard times with widespread unemployment and a slow economy. My father provided, on credit, milk and bread so his customers wouldn't starve. After things improved it was my job to go from door to door and collect what the neighbors owed.

Although money was scarce, we never realized we were poor and we were never hungry. Our meals were nourishing and cost very little. We had cheese, olives, pasta, garden vegetables, and plenty of fruit. Once a week, my dad would buy steak, probably at 5 cents a pound, and grill it in the coal-burning furnace. All of the above, plus the aroma of fresh hot bread, made us think we were richly blessed, and we were.

Although our family didn't drink wine, my dad made it to serve to our guests. I remember crushing the grapes and watching my dad as he carefully monitored the fermenting. Our guests always enjoyed our wine so it must have been good. At least it was fun to make and made my father feel close to his homeland.

I remember a funny story about the wine. My father always kept a bottle of it on a very high shelf. I wondered why and asked him about it. He just said it was good for wine to be kept high. I suppose he didn't want it to tempt us but it didn't deter my friend Antonette. She was nimble as a mountain goat and would climb up, get the bottle, take a swig and then replace it. I'm not sure if my dad knew or not. He never mentioned it.

When my sister Josephine started school she couldn't speak English. Italian was the language spoken in our home. However, it was not long before she could not only speak English well but became one of the best students in her class. English became her language of choice, but she also remembered the Sicilian dialect.

When Frances and I went to school, we no longer had a language problem. Now we spoke no Italian but secretly understood everything our parents said. This led to many happy moments when we learned things our parents never knew we understood. However, our ruse was over when our dad offered a challenge of five dollars to each of us if we would learn to read Italian. We each collected five dollars that day, a huge sum of money in that post-depression time. My father was so proud he couldn't stop bragging to his friends how smart his children were. That was the last time we learned secrets from our parents' Italian conversations. Now they knew and our game was up.

In the Italian culture, family is very important. I learned this because every Sunday all my

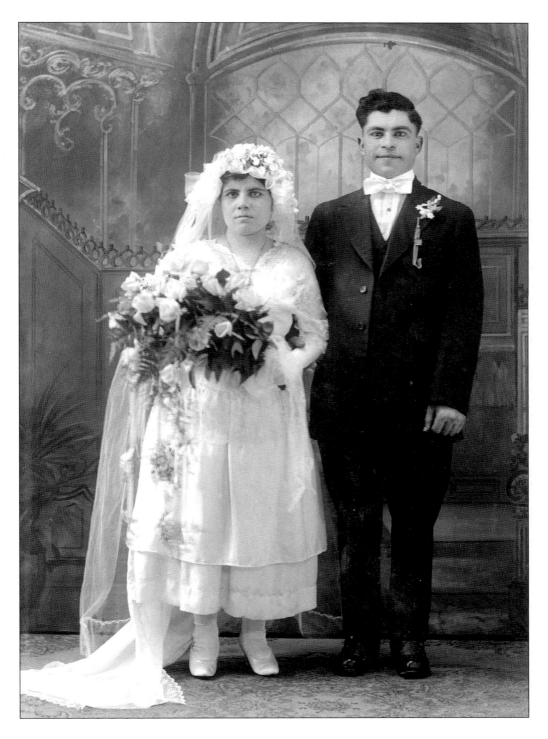

Josephina Ciaccio and Philip Ventura were wed at St. Rocco Church in Chicago Heights, Illinois.

uncles, aunts, and cousins met at Uncle Sam's tavern. The men played cards while the children drank coke and played games. My favorite was a machine that gave you a shock for a penny. All of us would hold hands and the one closest to the handle would hold it. The mild electric current that traveled through our bodies soon had us laughing and wishing we had another penny to do it again. It was cheap fun for all of us.

While the men played cards, the women gathered in the house that was attached to the tavern. They exchanged stories of their weekly happenings and discussed the best ways to serve the abundant produce from their gardens. They especially enjoyed talking about how many jars of tomato sauce they had canned for the winter. Their laughter is a pleasant memory I cherish.

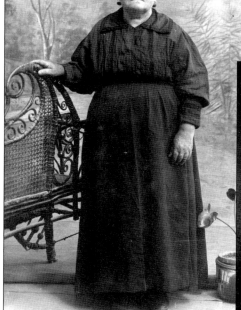

Below, Grandma Peppina Mendola poses with her daughter Marietta Ventura.

Peppina Ciaccio is pictured here relaxing in Sicily.

I also have fond memories of my Uncle Tony, who worked on the Illinois Central Railroad. My sisters and I walked home from school for lunch, so if we spotted him working on the tracks we would go home and tell our dad. He would always tell us to go invite him to our house for lunch. Then we would share our hot meal with him, usually a frittata (omelet) made of eggs, green peppers, or fresh asparagus. We also had hot Italian bread spread with olive oil and parmesan grated cheese. It was worth the mile walk just to smell the delicious odors and eat as a family, a deeply rooted need that was part of our culture.

However, I have to admit that once in awhile we would beg to eat lunch at school with our classmates. Then we would pack a sandwich and a 5 cent pie from the store. This was a real treat and didn't happen too often, so we really looked forward to it.

When I was seven years old my mother died and my dad decided to remarry. Leaving us in the care of Uncle Leo and Aunt Rose, he returned to Sicily and married Caterina Dioguardi, a friend and neighbor of his mother and sister. Their only child was born prematurely and died on their return journey to America. He was buried in New York and named Santo after my father's oldest son who had died of diphtheria.

My first teaching job was to teach my step-mom to speak English. It provided us many a laugh since she put the Italian "twist" on everything. Squirrel became "scuro" and no amount of practice changed that. However, she was able to communicate well enough to shop and travel to Chicago to see her brother Jim and family. She loved Aunt Jo, and her nephews Vince, Anthony, and Joe were her pride and joy. Her niece Genevieve became my childhood companion and together we managed to get into lots of mischief.

Aunt Jo and her family lived in Chicago near Wrigley Field and since she suffered from arthritis, Aunt Jo spent part of each summer in Bradley with us. She usually had little Joey with her and this led to some very interesting incidents.

Joey was the apple of *Zia* (aunt) Caterina's eye and she guarded him with loving attention. One day my sisters, Rosie Collins, and I took him to a carnival. They had the usual rides and Joey just loved the swings. He decided he would go on several of the whirring rides and refused to get off. When we finally persuaded him to get off he was so dizzy he could hardly walk. You can imagine the trouble we were in when she saw her favorite nephew in that condition. It was a long time before she forgave us.

During Aunt Jo's visits we tried to keep her supplied with fresh garden produce and healthy meals. This led to the need for a chicken coop since my parents decided chicken should be the main ingredient in each of her meals. Broth for breakfast, chicken and noodles for lunch, and some sort of chicken for supper. To this day I am not that fond of chicken, for obvious reasons.

Anyway, my dad and I spent many a happy hour building that chicken coop. First we had to dig an area near the basement. Then we poured cement for the walls and finished it off with various pieces of wood and chicken wire. I can still see my dad sweating profusely as we worked side by side. We were so proud of our work and I learned many important lessons from him. The one lesson that most stands out is that you don't have to be a carpenter to build. You can do anything in life if you plan and think things through.

My mom, Caterina, enjoyed America but missed her family very much. She was able to visit them several times and although she enjoyed the trips, she was happy to return to the luxuries she enjoyed in America. She died at the age of 96 after a happy life.

My two sisters married two brothers and raised their families in Bradley and Chicago Heights, Illinois. Josephine had one daughter, Nina, and Frances had three children, Alfonso, Joann, and Phil Marie. All of the children were immersed in the Italian traditions,

but they enjoyed the Italian food the most. Actually, it would be difficult to know the third generation was anything but 100 percent American. Knowledge of their Italian heritage remains minimal. However, a visit to beautiful Sicily could change that.

As the middle child, I was named Mary after my *Zia* (aunt) Marietta, my father's sister. When I visited her in Sicily, I found we were very much alike. We had the same sense of humor and love for people and nature. While I was there, she kept me up talking until the wee hours of the morning. "You can sleep when you get back to America," she said with a smile. We never ran out of things to talk about and I loved every minute of my stay.

At the age of 17 I joined the Springfield Dominicans and have been a religious for the past 55 years. It has been a time of joy with each day presenting a challenge and an opportunity to inspire students to follow in the footsteps of Jesus.

My ministry has covered the gamut, from teaching in first grade to college courses for beginning teachers. I have been involved in Religious Education for all of my 55 years, from preparation for First Communion to preparing handicapped adults for Confirmation. It has been a privilege to be involved in this program since I once attended CCD classes myself.

Even the summers as a religious have been interesting. For 16 summers I was the director of a migrant program in Mendota, Illinois. Children of migrant families who worked for Del Monte were able to continue their education during the summer. When they returned to Puerto Rico, Mexico, Texas, or Florida they were able to pass to the next grade, instead of repeating the grade due to long absences.

One year I was privileged to work with the Vietnamese "boat children" in Peoria. These teenagers were so eager to learn that we were able to place them in the public school system after a few months of preparation. Their success has been phenomenal.

Another of my summer ministries was working in a Day Care at the Alfred Fortin Villa in Bourbonnais. It was a fun time as I taught the little ones Spanish songs and prepared them for reading and math. Courtesy and prayer were also important as they learned to live a Christian life. Nothing is more satisfying than working with God's little ones.

Perhaps one of my more interesting summers was spent in Sicily teaching English as a Second Language. One of my students became a teacher and one a doctor. The others are continuing their education and doing well. Antonella, one of my English students, plans to visit me in the near future. She has always shown an interest in America.

Presently, I'm involved in a program for students who struggle academically. Essential Learning Solutions or ELS is a multi-sensory computer program that helps memory, processing and comprehension. It actually improves grades in every area and makes students independent learners.

Our ELS Program boasts 80 students from St. Bernadette's and area schools. Our youngest students are 6 years old and our oldest is 46. They come from Alsip, Evergreen Park, Oak Lawn, Orland Park, Blue Island, Western Springs, Oak Forest, and Chicago. Our rate of success has been phenomenal. Our parent company CEI, Creative Education Institute, located in Waco, Texas recently gave us some wonderful news. After entering the pre and post test scores from students in their 1500 labs, we rated as one of the three top schools. We were also awarded the status of "Exemplary Lab" for our efficiency and professionalism in our lab.

Perhaps the award that means the most to me is "Who's Who Among America's Teachers." I was nominated for this award by a former student and this makes it all the more meaningful. This is the second time I will be included in the Annual Edition of this prestigious publication, which lists the best teachers in America.

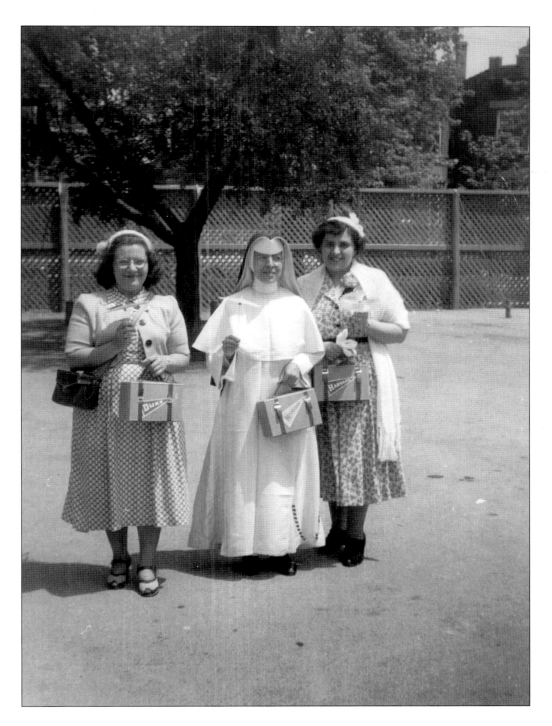

My sisters Frances and Josephine visit at Our Lady of Grace in Chicago.

Who would have thought that a child born to humble Italian immigrant parents would go so far? Who would have dreamed she would be able to touch so many lives? It is only possible because my parents taught me the value of hard work, the necessity of sharing my talents with others and the need for God in my life. They also instilled in me a deep love for my country, America, and a pride in all things Italian. I love America and I am so very proud of my Italian Heritage. Being an Italian-American makes me stand tall and fills my heart with hope. America can only be enriched by our love for her and the gifts we so generously share.

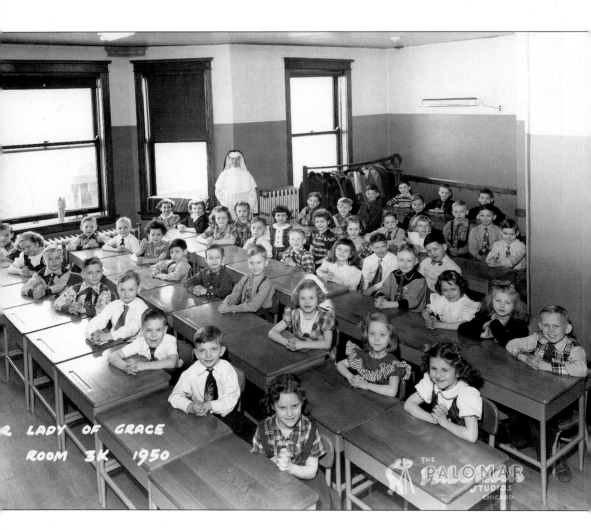

Sister Mary and her 1950 class at Our Lady of Grace are pictured above. Large classrooms were the norm in 1950.

Recipes

Sr. Mary Ventura

SICILIAN SFINGE

1/2 cup butter
1 cup boiling water
1 cup all-purpose flour
1/2 tsp. Salt
4 eggs

1. Melt the butter in boiling water
2. Add flour and salt, all at once
3. Cook over medium flame, stirring vigorously until dough loosens from sides of pan and forms a ball
4. Remove pan form heat and let dough cool slightly

5. Add eggs, one at a time, beating vigorously until dough is smooth
6. Drop by spoonfuls into hot oil. Dough will turn and plit slightly as it cooks (When the sfinge are done, they will be almost hollow and lightly brown.) Take each Sfinge out with a slotted spoon and place on paper towel. Sprinkle with granulated sugar.
7. EAT!!

WARM ITALIAN POTATO AND STRING BEAN SALAD

3 lbs Baking Potatoes
3 cans cut Green Beans
1/2 cup Vegetable Oil
1/2 cup Olive Oil
1/4 tsp Garlic
1/4 cup White Vinegar
Salt and Pepper to taste

1. Peel potatoes and cut into cubes.
2. Boil until tender (not soft).
3. Drain, and put into large bowl.
4. Drain green beans, rinse and drain well, add to potatoes.
5. Mix well.
6. Salt and Pepper to taste.
7. Add warm oils, vinegar, garlic and then pour warm mix over potatoes and beans.
8. Mix gently and serve warm.

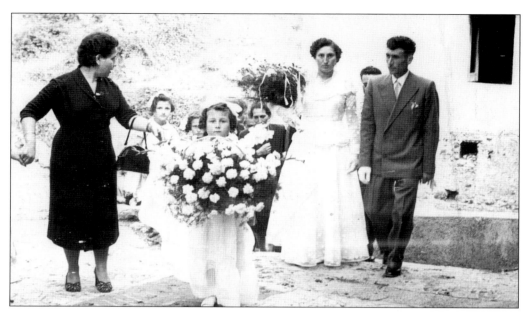

Donna on her way to church accompanied by Best Man Giovanni. The flower girl is her niece Antonette.

Donna and her father Giovanni Fornino followed by Vincenza (Maid of Honor).

Donna Fornino Gaetana DiMiele

Gaetana DiMiele's life in Italy and America

In the late 1890s, Gaetana Setaro married Giuseppe Fornino, a farmer from a small town in southern Italy called Sassano. Even though times were very hard they had eight children; Rosaria, Mary, Giovanni, Rosina, Dominico, Angelina, Vincenzina, and Giuseppe. In order to support his family during these times Guiseppe knew he would have to find better opportunities and America seemed to be the place to do that.

He left his family and moved to the United States. When he arrived in the states, he found a job, earned money and sent it all back to his wife and family in Italy. Upon his return all the money he earned in America allowed them to purchase farmland and other properties and live a very good life. When their oldest son, Giovanni (my father), was old enough to marry, he was given his portion of property. He married Vincenzia Tepadina (my mother) and together they took their property and built their own home and started a farm.

I was born in a small town in Provincial Salerno in a town called Padula. My father Goivanni was a farmer who grew everything to feed his family. I had three brothers (Enzo, Joe, and Frank) and one sister (Maria). I was the oldest of the five children in my family. I grew up during WWII; I was seven years old when Mussolini was in power. I remember the time when the German soldiers came and took over our house and farm. We went to live in the mountains in any shelter we could find. I remember when the Americans came and the war was over. We were happy to see the Americans. After the war, my family went back to our house and farm and began to rebuild what the German soldiers had destroyed. When I turned 17, I was promised to an Italian boy in South America. I had never met him, but my relatives arranged the engagement with him. We wrote letters but never met. We were engaged for one year when Giovanni DiMiele saw me in a wedding and wanted me to meet his son Salvatore. My father and Sam's father arranged for us to meet. We only met once and our parents arranged our marriage. Three months later we were married in a beautiful ceremony. After my wedding to Sam the boy from South America came back and wanted to beat me up because I had broken our engagement, but my father had him arrested and he went to back to South America and I never heard or saw him again. Twenty-one days after my wedding to Sam he left to go back to America; he had a thriving

trucking company that he needed to go back to. I was going to follow him soon after but I could not get what was called a quota number to get into the United States. Not only was I a new bride but I found out I was pregnant. I did not see my husband through the whole pregnancy. He was in America making a home for me and our new son Rosario, who weighed 12 pounds when he was born. I delivered him with a midwife in my in-laws home. I was in labor 48 hours with a room full of talking women, who had nothing better to do than talk about me while I was in labor. My son and I lived with my in-laws Giovanni and Carmela DiMile for two years until we were able to go to America to be with Sam. I got on an airplane with my child and arrived in New York on October 27, 1957. I was all alone and afraid that I would not recognize my husband, who I only knew for three months before he left. When I got off the plane, which had been changed from its original flight number, he was not there. The stewardesses walked me around the terminal to look for my husband, but I was afraid I would not recognize him. After about an hour we found each other in the terminal and we started off.

From New York the three of us took a plane to Chicago that same day. We lived in an apartment in Chicago for one year until we moved to a new home in Oak Lawn. In the new home I had another child, a daughter Giovanna (Joann). It was a cute three-bedroom bungalow that cost us $17,000 in 1958. I worked for a company called American tag on Sixty-third and State Street for two years. I learned to speak English from TV and at work.

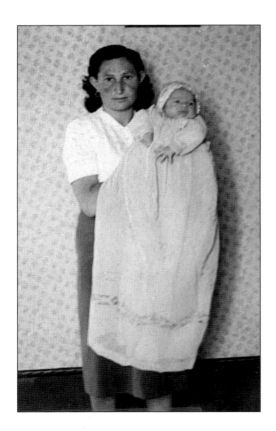

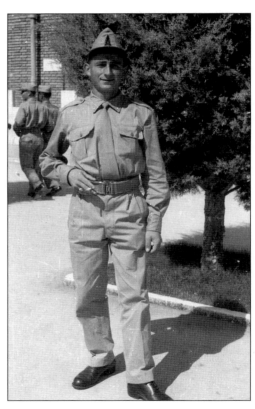

Donna with her first son, Rosario, at two months. *My brother Guiseppe in the Italian Army in 1959.*

My boss was a woman and very good to me. I did piece work and made $38 a week. My husband was a butcher for the A&P for nine years until he started his own business in meat wholesale. When Martin Luther King was murdered his store was vandalized, and he had to go into a new business, which I then helped him with. He opened a garden center and I gave birth to a beautiful daughter named Carmelina in 1967.

When I first came to America one of my biggest challenges was learning how to use all of the appliances and getting used to having electricity and running water indoors. Where I grew up in Italy we did not have washing machines and dryers or many other regular appliances that most American women had. We didn't even have electricity and running water in our home. My husband Sam taught me how to use the new gadgets that were in our home. I came to love the new conveniences that came with my new life.

I had to learn how to read and write by myself and more importantly I had to learn how to drive. My husband, with a lot of patience, taught me how to drive. We still had the landscaping business. Then in 1968, I gave birth to my last child Giovanni (John). From his birth I had a lot of medical problems. I had to have major surgery and a stranger had to look after my children because we had no family here to help. From that time on we always had our own business which I also worked at everyday and I was very active in the school system.

Even though this was our new home we still had many ties to our old home. We missed our family in Italy and whenever we got the chance we would go to visit or have them visit

Pictured above are Donna and her mother Vincenzina during a visit to the U.S. in 1979 for the occasion of Donna's daughter Joanna's wedding.

Pictured at right are Donna and her cousin Vincenza in 1954 in Salerno, Italy.

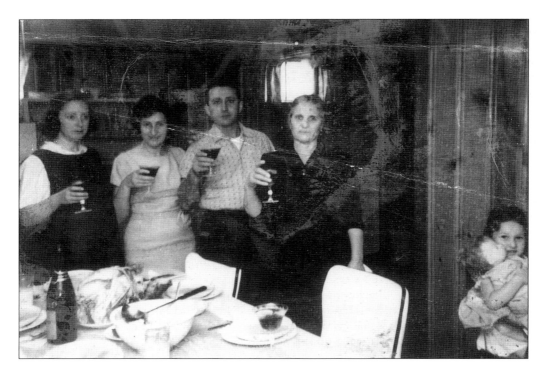

Donna and her husband Salvatore in the kitchen with her sister-in-law Eileen on the left and her mother-in-law on the right celebrating little Joanna's birthday.

Donna's mother Vicenzina at the age of 82.

us. It was always such a culture shock for them when they came here. Life was so different and sometimes difficult with long stays. On one occasion my mother came to visit and since she did not know any English at all it was very hard for her. My mother came to visit me four times before she died. Since we have lived in America, my father, mother, and brother Frank and his family have come to visit us.

Even though my family did not move here, my in-laws (Giovanni and Carmela) moved here for 15 years. After my father in-law retired from working as a machinist with a Chicago company, they moved back to Italy. Carmela also worked in a factory but never learned to read, write, or even speak fluently in English. They went back in 1973 and took with them a pension that they received in Italy until my mother in-law died in 1996.

Throughout the years, my husband and I raised our family. It grew from four children to four children, three in-laws, and seven grandchildren. During this time we made America our home and Italy our second home. We are proud to be Italians living in this country. We raised our kids to respect the laws of this country but to also have pride in being Italian.

In 1992, my husband suddenly died of a heart attack, leaving me to run our business and become head of our family. I eventually sold the auto repair center and sold my home in Palos Heights and moved to New Lenox. I am now retired but I certainly do not feel retired. I watch my beautiful granddaughter who keeps me young and very active. I get to enjoy all the things I missed while working in our business while my children were growing up. Being an Italian-American woman is something I am very proud of. I only hope I can pass that down not just to my daughters but to my granddaughters also.

Donna and Salvatore with their first son Rosario together with her husband's parents, Carmella and Giovanni.

Rose Frapasella, age 17; this portrait was taken in the Chicago Loop on Clark Street.

IV.

Rose Frapasella Stella

My mother, Josephine Frapasella, was born Peppina Capobianco on 33 Mulberry Street in lower Manhattan Island on August 23, 1884. She was baptized at Most Precious Blood located at 113 Baxter Street, New York City. My mother always said that she lived in Brooklyn, but we know that the Brooklyn Bridge and the Federal building were built in the year 1884 and 1889, respectively. The mailing address could have been Brooklyn at that time, but it is now lower Manhattan.

When my mother was only seven years old, she started taking care of her ailing mother in New York for the next seven years. My grandmother, Rosa Gagliano Capobianco, passed away in Chicago and my mother, her brother Joseph, and two sisters—Mamie and Maggie lived in Chicago with their father Cono Capobianco. My grandmother and grandfather were born in Teggiano, Italy in the Province of Campagnia. This town is within 30 miles of Salerno, Italy.

A friend of the family fixed my mother up with a widower by the name of Giovanni Frabasile, he was 12 years older than her. They got married. My mother was only 15 years old when she married my father, who was a U.S. citizen since age 20. My father became a citizen in Chicago in 1904 and they were married in 1909 at Santa Maria Incarnata which is now called St. Therese's Church at Wentworth and Alexander in Chicago.

There was a very traumatic period in her life. In 1933, the whole family was hospitalized except Conrad, Jennie, and I. It was food poisoning that had taken four lives. Two of the children were buried without my mother and father present at the funeral as they were in the hospital. I had to make the funeral arrangements along with my married sister, Angeline. My mother and father were on their death beds at Cook County hospital, where they received the sacrament of Extreme Unction and within days a miracle took place, they recovered. My mother had also lost a child from an unknown death now known as Sudden Infant Death Syndrome (SIDS). This woman suffered so much grief yet survived all of this sadness through the love she received from her neighbors and friends.

I was the third oldest of 14, so I helped raise the children. I couldn't attend high school because my mother needed me to help bring money into the household. I babysat and cleaned my aunts' houses. I remember my mother shopping on Twelfth and Halsted and Maxwell Streets for my clothes. She traveled without knowing how to read or write. She

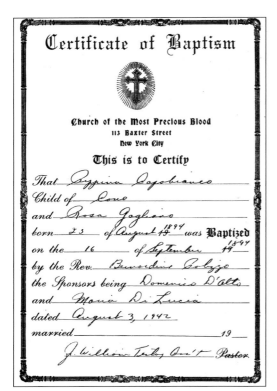

Certificate of Baptism

Church of the Most Precious Blood
113 Baxter Street
New York City

This is to Certify

That *Peppina Capobianco*
Child of *Cone*
and *Rosa Gagliano*
born *23* of *August 1894* was **Baptized**
on the *16* of *September 1894*
by the Rev. *Benardine Colizze*
the Sponsors being *Domenico D'Alto*
and *Maria Di Lucia*
dated *August 3, 1942*
married _____ 19 ___

J. William Teelay Con't Pastor.

Pictured at left is Peppina Capobianco's Baptismal certificate. She was baptized at the Church of the Most Precious Blood in New York City in 1894. She was born on August 23, 1894 on the lower east side of Manhattan Island in New York.

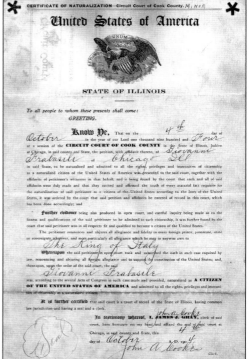

Giovanni Frabasile, born in 1884, Sassano, Italy, became a naturalized citizen on October 4, 1904 at the age of 20. At this time, he was still considered a minor. When he came to America he was married to a woman in Italy with whom he had twin boys. He was to call for her, but instead was called to her. His family was taken by the Typhoid Fever epidemic of 1905. He went back to Italy, buried his family, mourned, gave up his two homes, and traveled by ship back to America. After coming to Chicago, a friend fixed him up with my mother in 1909.

asked the street car conductor to let her know when she reached Twelfth Street.

As the years passed, she became ill with different ailments but her major health problem was diabetes and migraine headaches. Her life was taking care of children and visiting with friends and neighbors. There was a lot of comradery, with Josephine Romminelli, Dora Gallo, and Sarah Angone, who would visit with one another for lunch. My mother would bring homemade bread and fried cakes to her neighbors and friends whenever she would visit with them.

My mother and father didn't have much. I made Hires Root Beer at home and regular beer for my father with malts and hops when I was 14. We had a hand machine where you could put the bottle on the machine and my brother would cork it. We had no electricity

Pictured is the marriage license of Giovanni Frabasile and Peppina Capobianco. They were married on July 21, 1909 at Santa Maria Incarnata at Twenty-Third and Alexander in Chicago.

and would cork 50 (12 ounce) bottles for our own consumption every two to three months. I made Hires Root Beer every three weeks. Our choice of drink was root beer or water, every night. On the occasion we had milk, it was canned Pet milk in place of dairy.

The only form of entertainment I can remember with my mother is playing ball and jacks, hop scotch, and jump rope. We didn't have a radio or television, but we had music from our 78 rpm upright Victrola with a hand wind on the side. We had a four-foot wooden ice box kept in our kitchen. We would put a sign in the window when we wanted ice from the ice truck. The sign would read "25 lbs." It would last two to three days in the hot weather or a week in winter. We always had to have a pan under the box for drainage.

My father made red wine from grapes he bought, which would make 50 bottles of wine. He would put two wooden boxes of grapes into a steel tub, rig up a hose to connect to a wooden barrel for fermenting. He would then get his rubber boots, wash them thoroughly, put them on his feet, climb into the tub and start mashing his grapes until they were real dry. After they were dried, he would drain the fluid and let the grapes ferment in the barrel. He would continue to do this with the 25 boxes he bought. After a week or longer of fermenting, it was then bottled from the wooden wine barrel, which had a spigot. He made 50 bottles, which my brother Joseph corked and then placed them on a shelf in the cellar for a month or longer. This special wine was for his friend only. We did not drink wine at our meals for we had water or root beer.

As a family we did not attend Mass; only the children went to church together. My

mother always needed to attend to younger children in the house. One day, my father decided he was going to start attending Mass. He had to walk close to a mile to get to St. Cecilia's Church in Chicago. He was nearly there at about 7:45 a.m. when he stepped on a rake, which injured his eye. He had to come home because he was bleeding. While my mother was washing and bathing the eye, I heard him say, "See, I go to church and this is what happens. It wasn't meant for me to go to church." That was the last time he attempted to go to church, although he did request a priest give him last rights before he died in 1953.

My mother was given money each day to buy food for the family. Before my father started working for the City of Chicago, Bureau of Sanitation, as a street sweeper, he went junking on a daily basis. My father rented a horse and wagon everyday. He sold goods to the junkyard daily. Even when he worked for the city, he still went junking as the city did

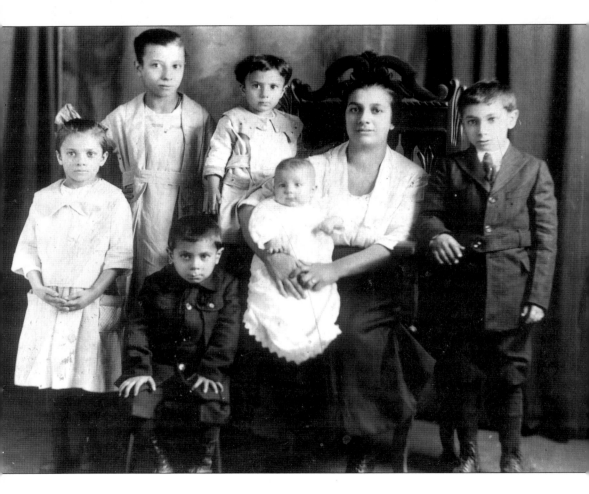

There were 14 children born to Josephine and John Frapasella. In 1921, my mother took a family portrait with the six children in the family at the time. Pictured, from left to right, are: (front row) Rose, Conrad, (Baby) Frances, (Mother) Josephine, and Joseph; (second row) Angeline and Jennie. Conrad and I are the only ones alive at this time. We are both in our 80's.

My only possession that once belonged to my mother is her locket, which she wore only on special occasions, including weddings. She is pictured here at a wedding, dancing with her only brother.

Pictured above are Giovanni Frabasile and Peppina Capobianco Frabasile on the second floor porch at Fifty-Ninth and Wentworth Avenue, above Glielmi Grocery Store, next to the eL.

not pay in a timely fashion and poverty was prevalent. My mother would go to the store and buy a sack of flour and my sister Jennie and I would take turns making bread. There were many arguments as to whose turn it would be, but I usually won as I was older than Jennie by more than four years. The boys in the family had it easy. They would help my father after school by going junking with him until they were old enough to work full time.

There were no gifts from my mother and father on birthdays or holidays, so when I would save some money I would buy the younger children toys. I bought Jimmy and Philip a xylophone and drum, which my mother hated because they would make too much noise. When I was 16 years old I had to turn over any money that I made to the family. My mother bought me my first birthstone ring for my 16th birthday; it was an emerald ring with three diamond chips. I loved it so much. I remember when I was in my 60's my daughter Annette bought me the same ring and I cherish it immensely.

In 1948, my mother and father purchased their second home, also a two-flat, two houses away from my husband John and I, at 5920 South Emerald Avenue in Chicago. It was so much fun because my sister, Angeline, the oldest in the family, rented our second story flat and my sister Theresa rented my parents second story flat. We would all go shopping and

to church together. In the evenings we would sit on our front porch and our whole family and many of our neighbors would congregate. The women would drink root beer floats on Fridays when the men had their beers and watched television at my sister Angeline's home. She was the first to have a TV. She bought a Philco in 1946.

We attended St. Martin Church at Fifty-Ninth and Princeton and our children, Annette and John Patrick, also attended school there.

In 1955, they purchased their third home. My mother sold the other two homes to purchase the newest at Seventy-First and Morgan Streets to be near her daughter Angeline and her family. She moved into Sacred Heart Parish and I moved into Evergreen Park, St. Bernadette Parish. My mother used to say that I moved too close to the railroad tracks and she was frightened to take the Western bus to see me because she would have to cross the railroad tracks to get to my home. My mother would need to be driven so we usually picked her up when she would come to visit. Of course, she was upset that we moved away from the city.

She lived in several apartments before she died in 1964 at age 70. With all of her many ailments, she lived a fulfilled life. She had a zest for life and enjoyed being with her many friends.

Portrait of the Frapasella family. Pictured from left to right are: (bottom row) John Stella Jr., Edith Frapasella, Jennie Ullrich, and Jerry Ullrich; (second row) John Stella Sr., Rose Stella, and Angeline Romeo; (third row) Annette Stella Dixon, Tony Frapasella, Josie Frapasella, Joseph Romeo, and James Frapasella.

Recipes

Rose Stella

ROSE STELLA'S ANISE COOKIES

1 1/2 Stick of butter (melt and cool)
3 Eggs lightly beaten
1 1/2 Cup sugar
1 Tsp. anise
MIX

2 1/2 Cups flour
1 1/2 Tsp. Baking powder
1/2 Tsp. Salt

1. *Sift and mix liquid mixture into dry mixture.*
2. *Make two long loaves.*
3. *Bake at 350 degrees for 20 minutes.*
4. *COOL*
5. *Cut diagnols, toast lightly on broiler or in oven.*

EASTER KNOTS

4 cups flour
4 tsp. Baking powder
1/2 tsp. Salt
6 eggs beaten lightly
1 cup sugar
1/2 cup oil
1 1/2 tsp. Lemon extract

1. *Sift dry ingredients in large bowl.*
2. *Blend eggs and remaining ingredients.*
3. *Knead dough until soft and smooth.*
4. *Break off pieces of dough about the size of a walnut.*
5. *Roll each piece with palm of hand and make a knot.*
6. *Grease pan lightly and bake at 400 degrees F for about 15 minutes depending on oven.*
Makes about 5 dozen cookies.

Portrait of Annette Stella Dixon at her First Holy Communion in 1950 at St. Martin of Tours Church, Fifty-Ninth and Princeton in Chicago.

V.

Annette Stella Dixon

Rosina Frabasile, born third out of a family of 14, was a quiet, shy child. When she was just one year old, in 1916, her older sister Angeline spelled their surname as Frapasella, when Angeline entered Colman School located at 4500 S. Federal Street in Chicago. Thus, a new family name was born because their mother, Peppina, could neither write nor read. In those days, a name was not that important for identification, once one became a citizen. Neither Peppina nor Giovanni were employed that year. Giovanni had a horse and wagon and went junking in the city of Chicago.

Because my mother, Rose, was intelligent and always interested in school, she was double-promoted in the second grade. After she graduated from the Eighth grade in 1930, her mother would not allow her to attend school. She was needed at home to help raise the children and earn money to help with expenses. In between raising the children and doing housekeeping, Rose would go to the library and borrow textbooks, for she loved reading and learning.

At age 17, Rose started a full-time job at Sopkin Garment Factory, located at Forty-Ninth and State Streets in Chicago. She worked there for 10 years and became an inspector rather than a seamstress. She also taught and became a floor lady, responsible for overseeing a small crew and ensuring that they were completing their jobs. While she didn't have time for dating, she managed to be engaged at least three or four times.

At age 27, Rose fell in love and married a bilingual Italian American. Louis DeChristopher was very meticulous with his seven suits and wore a different one each day. After they were married he lost his construction job and never replaced it. He told my mother and grandfather he got money the easy way. He never said exactly what he meant, but a short time later he was picked up by the police and arrested for theft. He served six months in the county jail.

My mother didn't know what to do since she was pregnant with me and she hoped things would get better. She waited for Louis to be released from jail, but things did not work out so she filed for divorce in 1943 and received the decree. As a divorced parent, she went to work full-time and her sister Angeline babysat me. I only saw my father, Louis DeChristopher, until I was three. After that we remained in hiding. My mother feared he would kidnap me and harm her, even though she had remarried in 1946.

Rose and Louis DeChirstopher on their wedding day. Louis was 31 and Rose was 27; it was their first marriage.

Rose Stella and daughter, Annette Dixon, in Little Italy in New York City. Columbus park is located on Mulberry Street, home to Josephine Capobianco Frapasella, where she was born and raised.

John Patrick Stella, Rose's new husband, lived in the neighborhood around Fifty-Ninth and LaSalle Streets in Chicago. He served in WWII and when he was discharged from the army in 1946, they got married. The marriage was held in the City of Chicago's courtroom; therefore when John Patrick Jr. was born, Father McKay from St. Anne's Church wanted my mother and father's marriage blessed before he would baptize my brother. My dad, John Stella, adopted me when I was four and I was very close to him until his death in 1999.

My mother and father both sacrificed to give me everything I needed to further my education. I had a piano at age 8, before my parents bought a car or television for themselves. I had the piano until 2002 when I moved back with my mother.

In 1956, my mother needed to earn money for my brother and my Catholic education, so she went to work at Duball Manufacturers at 5700 S. Lowe Avenue in Chicago. That same year we moved to Evergreen Park in a new home that was custom built by Erickson. She continued to work at different companies until 1977, when she retired at age 62.

After her retirement, my mother helped me with baby-sitting and with my business and then she started to travel. In 1981, my mother and father traveled with me to Italy. We went to see a friend in Soviano, Naples and continued to travel throughout Italy. It was my mother's first airplane ride, a 12 hour-long trip on Alitalia. In 1981, she was 66 and a great traveler. My dad, 70, was wonderful to be with; we navigated through the country without knowing how to speak Italian.

My mother traveled to Canada, Michigan, Indiana, Missouri, Rhode Island, New Hampshire, Wisconsin, Massachusetts, and Tennessee with my father and our family. In 1999, my mother and I traveled together east. We spent time in Indiana, Washington D.C., Pennsylvania, West Virginia, New York, New Jersey, Delaware, Maryland, and Virginia. I mention this because my mother and father never traveled until their later years. They would only travel with us and never alone. My mother envied her sister, Angeline, who traveled to 48 states plus Cuba and Italy while she was young. But Angeline was unable to travel in her later years. It was just the opposite for my mother.

My mother taught my brother and I to enjoy our education and gave us many opportunities to do so. John became an evidence technician for the Chicago Police Department. He retired from the force but currently works in Lemont.

I am the publisher and editor of three newspapers under the corporate umbrella Village View Publications, Inc. John and I have Bachelor's degrees; John's degree is in Law Enforcement and mine is in Media Communications. Even though my brother and I returned to school as adults, our desire to learn stemmed from the example set by our mother. At age 87, she still reads novels and enjoys word puzzles and cooking for our family.

ANNETTE DIXON

Autobiography

My growing up was quite difficult for my mother and me. My mother was divorced when I was one year old. My Aunt Lilly, Angeline Romeo, watched me during the day and my mother took me home in the evening for four years. My life took an obvious turn when I was three, for one night when my cousin Lucille and my Aunt Theresa were dancing to the latest bee-bop tunes, they lost sight of me. I climbed onto a chair and fell off and lost my two front teeth. Well, it was at that instant that I became defensive, a trait that has stayed with me ever since. I was teased until I was seven when my new teeth broke ground.

At that time, I lived at Fifty-Ninth and Wentworth above Glielmi Grocery Store. Pasquale and Vidale Glielmi owned the store. One of their children, Larry, is currently part of the St. Martin Parish group that meets at Hackney's Restaurant in Palos Park on the last Monday of every month. We lived so close to the elevated train that when it went by my friends and I would dance, sing, and wave to the people. They, in turn, would throw money, candy, and cigarettes to us. Also at age three, my uncle Joe Romeo would call me Walter Winchell because I talked too much. My cousins, Lucille, ten years older than me, and Frances, five years older than me, treated me wonderfully. They took me out with them often and watched over me like a mother hen. I remember Frances always introducing me to her friends and even allowing me to be with her and her friends at the beach in the summer time.

I always had two sets of friends—classmates and neighborhood friends. I also tried to acquire new friends. I remember getting to know everyone within a four block radius of our home. My mother would always punish me for not coming home on time. Moreover, I did volunteer work for seniors by doing errands. I also had a daily job for Miss Forsberg, a next door neighbor who was my piano teacher. She hired me to weed her grass and garden everyday, burn her garbage weekly, and just sit with her and talk. At that time I lived at Fifty-Ninth and Emerald and our back yard faced the backyard of businesses, with an alley between us. My business experience started when I met several Jewish proprietors who paid me to go junking for them. Their request was mostly for glass. I remember one time I found blue glass in large sheets. I sold the glass to Mr. Curtis and within three months that same blue glass was under the cross of a crucifix hanging in the store window. I wanted it so badly, one for my grandmother and one for my mother. This was my first lesson in business. I remember what he gave me for a sheet of glass versus the $10 I paid for the two crucifixes. We still have the crucifix.

My Uncle Philip, who I admired because he was happy all the time, made the teenagers who hung out on the corner leave me their soda bottles so I could get the deposit. Even my Uncle Jim used to get yelled at by Phil because he would get his deposit and didn't leave his bottles for me to pick up. Just about everyone encouraged me to work. My first real job came when I was 11 years of age. I babysat several days a week for Emily and Jimmy Glielmi, a newly married couple with a beautiful baby boy by the name of Michael. At age 14, I worked at a show near Sixty-Third and Halsted for 50¢ an hour and all the popcorn and candy I could eat. I worked 30 to 50 hours per week just to buy the clothes I wanted. The first item I purchased was a $64 blue cashmere coat at Morris B. Sachs. My mother

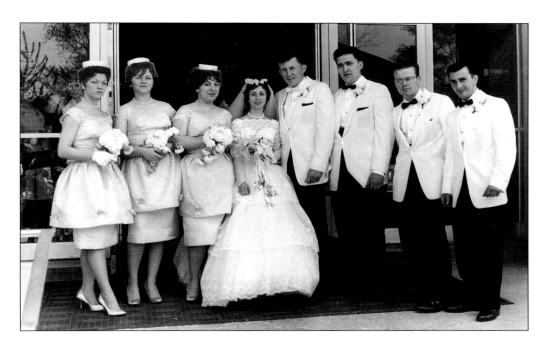

The wedding party of Rich and Annette Dixon. The couple was married on May 13, 1961. Included in the wedding party, from left to right, are Jane Weeks McIntyre, Patricia Nealis Regas, Rose Ramirez Kessler, Annette and Richard Dixon, Leroy Seratin, Tom Neal, and Anthony Frapasella.

The bride's family—mother, Rose Stella; Annette; father, John Stella Sr.; and brother, John Stella Jr.

Annette Dixon has been politically active in the GOP for the past 40 years.

ILLINOIS HOUSE REPUBLICAN CAMPAIGN DINNER with

Gerald R. Ford

Gerald R. Ford

President Gerald R. Ford

HOUSE REPUBLICAN CAMPAIGN DINNER
July 16, 1986–Palmer House

A DINNER HONORING:

OUR ILLINOIS REPUBLICAN STATE REPRESENTATIVES

House Republican Leader
Lee Daniels

Chairman
Clarence E. Neff

House Leadership
Jack Davis
Thomas W. Ewing
Dwight P. Friedrich
John W. Hallock, Jr.
Gene L. Hoffman
Penny Pullen
Sam Vinson

House Members
Ralph H. Barger
Jane M. Barnes
William B. Black
Robert W. Churchill
John W. Countryman
Mary Lou Cowlishaw
Suzanne L. Deuchler
Loleta A. Didrickson
Virginia F. Frederick
Charles Wayne Goforth
David Harris
Karen Hasara
Dennis "Denny" Hastert
Carl E. Hawkinson
Donald N. Hensel

Timothy V. Johnson
James M. Kirkland
Dick Klemm
Judy Koehler
Jack L. Kubik
Jeffrey D. Mays
Roger P. McAuliffe
Thomas J. McCracken, Jr.
A. T. "Tom" McMaster
Myron J. Olson
Margaret R. Parcells
Terry R. Parke
Bernard E. Pedersen
William E. Peterson

Robert J. Piel
Robert P. Regan
Gordon L. Ropp
Tom Ryder
Kent Slater
James R. Stange
Ron Stephens
Michael J. Tate
Fred J. Tuerk
Ronald A. Wait
Michael "Mike" Weaver
Linda M. Williamson
Kathleen "Kay" Wojcik
Jill Zwick

OUR ILLINOIS REPUBLICAN REPRESENTATIVE CANDIDATES

Jay Ackerman
John Allen
Paulette I. Anderson
Robert H. Anderson
Matthew J. Baker
Phillip Bianco, Jr.
John E. Bobel
Billie Jean Buckley
Doris L. Boynton
Margaret S. Cartright
Mary Ann Chohrek
Jon Colt
Marshall R. Crawford
Carol J. Dannenhauer
Annette Dixon
DeLoris Doederlein
Becky Doyle
George Each

Jerry Ex
Mary E. Fickenscher
E. R. "Dick" Friesth
Robert "Bob" Goins
Gerald C. Harper
Charles "Chuck" Henderson
Marjorie Ann Hoeller
Kenneth H. Hollander
David Hultgren
Fawn V. Hurst
Paul J. Jankauskas
Robert B. Jans
Joseph M. Jenco
George Johnson
Direoce Anthony Junirs
Guy Lahr
Daniel A. LaKemper

Virginia V. Mann
Sheldon Marcus
Mark B. McLeRoy
Charles "Chuck" Mobley
Fernando Murillo
Bob Nika
John Peter O'Toole
Carol Panek
Robert A. Pfluger
Marie T. Pikul
Frank R. Ranallo
A. A. "Sammy" Rayner, Jr.
Michael Roche
Archietta Shannon
Todd Sieben
Warren W. Sikorski
Brian C. Silverman

Stanley C. Sobrya
John R. Spaulding
Winston Springer
Marvella Stewart
Lee O. Sturgis, Sr.
Kevin Sykes
Cornelius J. Tanis
Mildred J. Thompson
Dennis F. Villare
Jonathan M. Walker
Gerald "Jerry" C. Weller
Dan Whitlock
Gene H. Wolfe
Donna L. Woodrow
Cecil Wyant
Herman F. Wright
Anne F. Zickus

Annette, Rose, and John in Italy.

used to say if you want nice clothes, you have to work for them. She felt that my cousins hand me down clothes were good enough. I didn't feel the same way.

When I got married to Richard C. Dixon, he had a great job at Agar Meat Packing and he preferred I didn't work, so I didn't. I gave up a wonderful job as a private secretary at Foote Bros. Gear and Machine Corp. where I had made more money than he did per hour. In 1961, I made $3.65 per hour, and time and a half for overtime. Soon Rich was reactivated in the army because of the Berlin Crisis when President John F. Kennedy recalled the reserve troops to active duty. Times were difficult during that period, because we lived in Alabama during the 1960s, when the buses were torched and Martin Luther King marched through Selma, and yet we survived.

In 1963, Rich and I purchased our first home in a Chicago neighborhood called Scottsdale. That is where I first began my volunteer church work. Not only was I a member of the St. Bede Looney Tuner Band, but I also taught and was a teen moderator for St. Bede School and Church. I also helped with fundraising for the St. Bede Altar Guild. My childhood experiences of being with people older than myself helped me experience a new life as a young adult. I can remember being one of only a few Republicans in the 18th Ward, but it was fun knocking on doors during the Nixon/Kennedy election campaign. It wasn't until 1970, when we moved to Oak Lawn, that I became established within the community. After getting involved in St. Gerald Parish as a volunteer, working for Vina O'Malley at the *Village View* newspaper, and campaigning for all of the Republicans who ran for office, I became known in the village.

In the meantime, Richard and I adopted two beautiful children. Michelle arrived in 1966 and Lance followed in 1970. I was fortunate to be able to stay home with them through

Rose Stella's cousins, Guiseppe, Giovanni, and Ms. Abbruzzese in Sassano, Italy, in 1981.

A family dinner at the Rose home in St. Joseph, Michigan. Pictured from left to right are Darlene Rose, Annette, Michel Rose, Richard, Rose Stella, and Stella Saenz.

Lance Dixon, holding son Henry, and Benjamin standing near, are pictured near Dixon Graphic Equipment.

most of their elementary school years. I believe that I have passed on the value of strong education and life-long learning to my children.

It was during the 1980s that the St. Gerald Ministry was developed. I was happy to be a part of that service. My volunteer career expanded into St. Gerald Parish and yet I remained faithful to St. Bede's Looney Tuners and Mary Kay Blake, our choreographer and producer/director. It was a long arduous journey of entertaining, attending college, and raising two children.

In 1990, our country attacked Iraq and the Gulf War began. I remember clearly how frightening it was downtown on the day we attacked Iraq. My daughter was in Navy Communications and I felt it was my duty to do something, so I met with Lt. Ralph Eldridge, Director of the USO (United Service Organizations) for Illinois and I told him I was going to petition the Aldermen and Mayor Daley to allow the USO to be established at Midway Airport. It took many volunteers and three weeks before I got the news from the City of Chicago mayor's former press secretary, Avis LaBelle, who came to tell me that Midway Airport would provide the space for us to set up a USO headquarters. With the help of Veterans groups, Amvets, local volunteers form Oak Lawn such as Bernie O'Malley, and other tradesmen who donated their time and money to install cabinets, counters, etc., we had our headquarters.

Between 1989 and 1995, I became a substitute teacher once again. I started a flyer delivery service from 1988 until 1998 called ADD Flyer Delivery Service. I surely had fun and made money along with the many children and seniors with whom I worked. My biggest customer was Phil's Pizza on Eighty-Ninth and Ridgeland in Oak Lawn. He loved our service and we loved him.

From 1983 to the current year I have been publisher of the *Village View* newspaper. It is rewarding and stimulating. It wasn't until 1998 that another segment of my life began. It was the formation of the Italian-American Women's Club, founded by Sister Mary Ventura and myself. It serves women of Italian descent and helps them to communicate and focus their talents, desires, and foreign language skills. We enjoy learning about what our predecessors have accomplished both in Italy and in the Chicagoland area.

Richard C. Dixon, my husband of 41 years, is ready for retirement on July 30, 2003. I am sure there are new roads ahead, for we will keep the *Village View* newspapers and intertwine our lives with our children and grandchildren, who live out of town. Who knows what dreams and realities will be in the future?

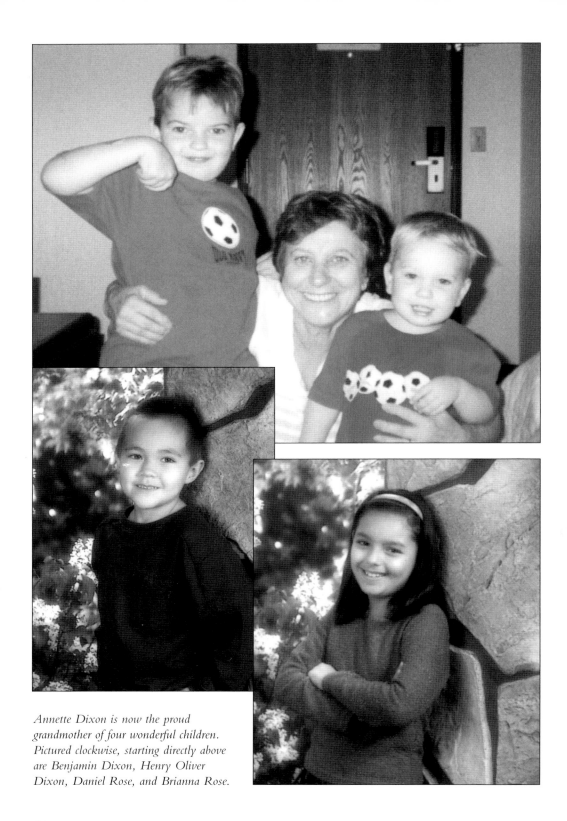

Annette Dixon is now the proud grandmother of four wonderful children. Pictured clockwise, starting directly above are Benjamin Dixon, Henry Oliver Dixon, Daniel Rose, and Brianna Rose.

Recipes

Annette Dixon

EGG BREAD

2 Cups water
6 Tablespoons margarine
3 Eggs (beaten)
1/2 Cup sugar
5 Cups flour
2 Teaspoonfuls salt
1 Package dry yeast
3/4 Cups raisins

1. *Boil one cup of water with margarine and salt. Add sugar.*
2. *Pour this into a large bowl; add cup of cold water and let the whole cool.*
3. *When cool, add yeast, and 2 beaten eggs and stir.*
4. *Add 2 cups flour and mix until smooth. Add 2 more cups flour and raisins, and mix well. Add last cup flour, and mix.*
5. *Allow the dough to rise for one hour in the bowl.*
6. *Divide the dough in six pieces. Then, using a floured board and floured hands, fashion each piece into 12-inch rolls. Take three rolls and form into a braid, turning each end under to seal. Do likewise with remaining rolls.*
7. *Place each loaf on greased baking sheet and allow to rise for 1/2 hour.*
8. *Beat third egg and brush on loaves. Bake at 375 degrees for about 40 minutes.*

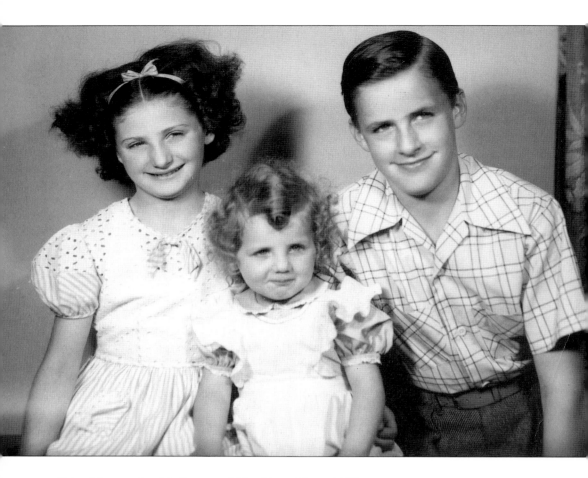

Pictured here are Lorelei, Penny, and Ken Naponiello c. 1947.

VI.

Lorelei Naponiello Cartolano

My grandmother, Lucille Naponiello, was barely able to fulfill her role as grandmother. She died at the tender age of 49. Yet every memory bank I've tapped into attests to her strong sense of purpose. She, her husband Joseph, and their two small children, Carmella (age two) and Rose (age one), left a little inn they owned in the village of Oliveto Citra, a province of Salerno, Italy in 1900 to come to Chicago. It had been Joseph's dream to return to America ever since he had lived there for a few years as a child. Grandpa was in Chicago just after Lincoln's assassination, when he was lying in state in the old City Hall.

The Naponiello family settled in Chicago on Plymouth Place. There they opened a full grocery store and were able to provide for their ever expanding family. They had four more children: Josephine, Nick, Joseph, and Antonia.

While juggling a business and caring for their six children, they acquired farm property at the Archer City limits, now known as Argo. They then moved to 1428 S. Wabash, which was directly across the street from the old Chicago Coliseum. It was here that Anthony and Angiolina were born. Sad to say, Antonia and Angiolina did not survive infancy.

In 1912, the family made their final move to 500 West Twenty-Fifth Street in Bridgeport, an area where many Naponiellos are still in residence. And in 1913, their last child, Angeline, was born. Eventually the family acquired a tavern. There were strict laws governing drinking establishments at that time, and one of them dictated that only men were allowed in taverns. Therefore dividing walls had to be erected so women and children could come and purchase beer in dad's beer bucket without breaking the law.

Grandma Lucille turned this problem into an opportunity. She opened a restaurant on the public side of the partition. This was a novel idea for that era and proved to be very successful. On the weekends Grandma would gather her lady friends together and head to her farm to harvest the bounty which she then served at the restaurant.

Being very responsive to the needs of her parish, Lucille organized the first of many parish carnivals. All Saints church was predominately Italian so they had neighborhood Saints processions, which were reminiscent of those from the old country. They even had tiny angels suspended from cables that helped them "fly" across the street assisted by pulleys.

One year, a new recreation hall became a very important need. At a carnival earlier that

The Chicago Court House, where President Lincoln lay in state in 1865, is pictured here. It burned down in the Great Chicago Fire of 1871. My grandfather was in Chicago at this time and remembered this event even though he was only five years old.

The Naponiello Tavern is shown here c. 1919. Lucille had her restaurant behind the partition. Her husband, Joseph, is behind the bar.

year, the parish priest insisted he wanted to be in charge of the fireworks. Unfortunately, due to his inexperience, the fireworks went out of control and the old hall burned to the ground. Needless to say, the proceeds from that carnival went toward a new recreation hall.

As each of her daughters married, Lucille provided them with the traditional trousseau. She gave them homemade bedspreads of satin and lace, and linens with crocheted edgings. No Italian could marry without a trousseau.

Soon after my grandma's death, my grandpa sold her beloved farm and invested in a large truck garage on South Clark Street. It was not only a good source of income, but also the site of a famous family occasion—my parents wedding celebration! The garage was the only place large enough to accommodate the immediate family, the extended family, and the bushel baskets of food lovingly prepared by my aunts.

My dad, Anthony, married Anna Molitor in 1935. My mother and father loved to go dancing; three of their favorite haunts were White City, the Aragon, and Treinon ballrooms.

My mother, Anna, was a third generation American. Her family came to this country in 1874, three years after the Great Chicago Fire. She was the oldest of 12 children and the sole supporter for her family during the Great Depression. Her first job was at the Boyer

Grandma Lucille, Aunt Angeline Naponiello Taylor, and Anthony Naponiello c. 1924.

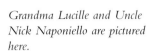

Grandma Lucille and Uncle Nick Naponiello are pictured here.

Anna Naponiello (nee Molitar) was a Boyer Model. This photo was taken c. 1935.

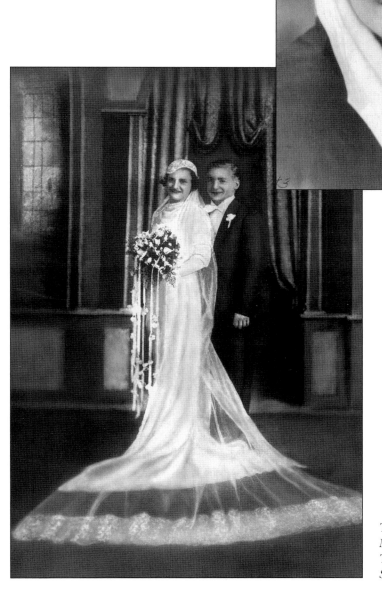

This is Anthony and Anna Naponiello's wedding photo. They were married on September 8, 1935.

Chemical Company, the Mary Kay Cosmetics of their day. She worked in the business office and, on account of her striking beauty, Anna was also an on-staff model, displaying the new cosmetics for potential buyers. During the evenings, she attended Wright Junior Business College and excelled in Pittman Shorthand and typing. In 1929, she became one of the first women in Chicago to earn a driver's license.

In December of 1941, my parents realized their dream of opening a restaurant. This coincided with the bombing of Pearl Harbor. While my Dad spent the next 45 years working for the City of Chicago, my mom and my Aunt Rose ran the restaurant business. They continued this line of work until they were well past retirement age.

My brother Ken, my sister Penny, and I (Lorelei) were raised in a very secure environment. Between my dad's seven and my Mom's eleven brothers and sisters, we had very eventful lives. Twice a week we made trips to my Uncle Nick's delicatessen to buy fresh meat for our restaurant. As we left, he always tucked a toy under our arms.

When Uncle Nick sold the Deli and opened a bowling alley, we thought that was the end of the toys. Not so! It was the only bowling alley I have ever been in that had a line of toys. At the Grand Opening he reserved an alley just for kids and even provided mini-bowling

Aunt Josephine Naponiello and husband John Kallenborn.

The oldest child, Aunt Carmella Naponiello Coglianese is pictured here.

Pictured, from left to right, are Anthony and Joseph Naponiello, Rose Naponiello Gleason and Jeanette Piegari Naponiello, Uncle Joe's wife.

balls so we would not be left out. Uncle Nick also owned a theater called "Norwal" because it was located between Normal and Wallace Avenue.

Thursday night was spaghetti night at Uncle Joe's tavern. Since he was my uncle, the whole family was able attend. He also had a line of toys. When we left he either slipped coins in our pockets or stuck toys under our arms. I am the only person I know who was able to celebrate New Year's Eve parties in a tavern as a child. These parties were extra special since my father's birthday was January first.

Once a week I had a dance lesson at my Aunt Angie's studio. Angeline's School of Dance was quite famous because her dancers were invited to participate in the 1933-34 World's Fair in Chicago. Uncle Joe's daughter Lucille was a dancing butterfly in the troupe. Sally Rand performed nearby and liked to spend time with the other dancers from Aunt Angie's group since she was very young at that time. According to my cousin Lou, the controversial Sally Rand did wear a body stocking, contrary to popular belief.

When my dad and Aunt Angie were in grammar school and they wanted extra money, they would go to North Pier, which was then a wholesale flower market. They would buy flowers, make them into small bouquets and sell them on State Street.

Aunt Rose and Aunt Josephine were excellent cooks. One of my fondest memories is going to their houses on a Sunday and not being allowed into one of the bedrooms. This room was reserved as a drying room for the ravioli. The bed would be covered with a clean sheet and the ravioli would be placed on it in a single layer. Then a second sheet was placed over the ravioli until they dried sufficiently to cook. The number of people eating determined how many beds were off limits. But one bed was always left to deposit coats and hats on. Once the ravioli were ready to eat, their famous words were "eat, eat!" or "manga, manga!" I have and cherish some of their original recipes.

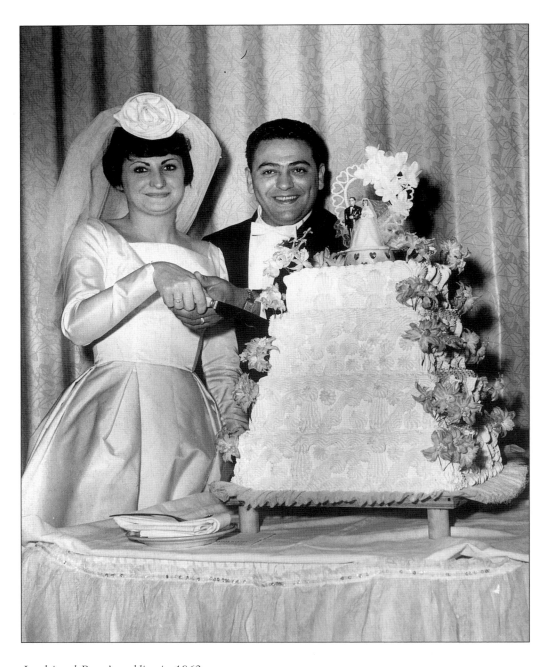

Lorelei and Rocco's wedding in 1962.

The Carolano family, from left to right are Lorelei and sons Anthony and Rocco. Seated is daughter Candice.

Aunt Carmella owned a pizzeria on Eighteenth Street near Ashland. She was an excellent baker and whenever we visited her there was always something fresh and wonderful to eat. Aunt Carmella knew the meaning of the word "abondanza" or an overabundance. You could always count on what she baked to be hot, delicious, and plentiful.

When my father died at the age of 90, one of his kindergarten classmates attended his wake and gave us a glimpse into his wonderful sense of humor. "I couldn't miss this wake; Anthony was always such a devil!" Then she explained how, when they started school at Mark Sheridan School in Bridgeport, Anthony was the only one who could speak English. As translator he got them all in trouble with lots of misinformation laced with swear words. The teacher finally figured out what was happening and straightened him out.

The Pastor in the parish had a parrot that he put on the porch before going to say Mass. Anthony would stop to visit the bird and teach him some choice swear words. One Sunday the Pastor asked the congregation to come forward if anyone knew who had corrupted his bird. Now I know why my dad was so strict with his children.

You were in trouble if you tried to shake his hand. Hugs were always required no matter how old or big you were. He was a great dad and the only father I knew who could tap dance. My grandmother's children had embracing personalities and they are a sincere tribute to their mother.

When I was a child, our Sunday dinner was always an important gathering. We usually had company and being on time was a priority. Spaghetti, meatballs, and sausage followed by chicken or a roast were the norm. Our non-Italian friends were amazed that we had so many different meats at the same meal.

Eating together as a family was part of our tradition. Whenever someone had a legitimate reason for being unable to do so, we reworked the schedule until everyone could be present. My parents were always upset that modern day families seldom eat together.

Monday would always mean meatball sandwiches in my lunch box. The children at school always accused me of eating dog food sandwiches. They were actually meatball sandwiches to die for.

My best friend, Rocco Cartolano, and I married in 1962. A few years later we found a house in Oak Lawn, Illinois that we considered a buy. When we asked my parents for their opinion, my mom, who had a way of sugarcoating things, said, "It's not bad!" My dad, who always told the truth, said, "It's a dump!" However, he must have had lots of faith in our rehab ability, since he lent us the money for the down payment. After three children, Anthony, Rocco Jr., and Candice and two rehabs later, we still reside in Oak Lawn.

My husband Rocco came from a family of nine children and was a first generation Italian American. He worked for an import liquor company for 38 years and provided very well for us through all of our rehabs.

In 1985, I opened an antique business on Beacon Avenue in Orland Park. Although Rocco was not thrilled with my new undertaking, he was supportive; providing lots of cash and muscle. It proved to be quite a venture that lasted for five years until his death in 1989.

The time then came for a serious job and a dear friend found me employment in a nursing home. I worked as a therapeutic recreator for 11 years. For 7 of the 11 years I was the program coordinator in the Alzheimer Unit. These were happy and productive years.

I am now a senior citizen, retired from the work force and teaching my seven grandchildren, Nicole, Natalie, Kayla, and Kelli Cartolano; and Roxy, Edward, and Angel Fitzgibbon how to tap dance. In the tradition of my grandmother Lucille, who I never met, I am a compulsive gardener, which made me come to the conclusion that we are all tied together at our roots. What a glorious heritage!

Recipes

Lorelei Naponiello Cartolano

ROCCO'S ZUCCHINI SOUP

6 Quarts of Water
6-10 Beef Bouillion Cubes
(During Lent use vegetable cubes)
1 large or medium zucchini, cubed
1 medium onion, diced
1 28 oz. can of diced tomatoes
or can of tomato soup

1. *Place all ingredient s in a large stock pot until vegetables are tender.*
2. *Whip 6 eggs with a fork.*
3. *Bring Soup up to a rapid boil. While stirring the soup, begin to drizzle the eggs into the soup. Break up any large chunks of egg.*
4. *Add 1 cup of Acini di Pepe or any small pasta. For thicker soup, add another cup of pasta. Cook until tender.*
5. *Salt and Pepper to taste.*
6. *Cut diagonals, toast lightly on broiler or in oven.*
7. *When serving, top with grated Romano cheese.*

CHEESE PIE PASTADA

1 lb Ricotta cheese
(if too wet, drain)
2 eggs
(if Ricotta is dry, add 1 more egg)
1/2 tsp. Vanilla
1/2 cup sugar
4 oz or 1/4 cup of cooked and cooled Acini Pepe

1. *Preheat oven to 350 degrees.*
2. *Make your favorite pie crust recipe and fit pastry into pie pan or buy a frozen pie shell (9 inches).*
3. *Coat shell with a beaten egg white and set aside.*
 To make filling:
1. *In a medium bowl beat ricotta cheese until creamy.*
2. *Add eggs, vanilla, and sugar.*
3. *Beat until blended.*
4. *Fold in cooked and cooled Acini Pepe.*
5. *Bake about 50-60 minutes or till center of filling is set.*
6. *Make sure to wrap a strip of foil around the edge of the crust to prevent burning.*
7. *Cool on a wire rack.*
8. *Refrigerate until cold.*
 Serves 8.
For cheese slices use your favorite ravioli pastry recipe and fit into a 9 by 13 inch pan. Double filling recipe.
Yields:
1—16 oz. Box of Acini Pepe yields 8—1 cup servings when cooked.
1—5 lb. Container of Ricotta yields 10 cups (8 oz cups).

Mary Lou Farino at age 3 years.

Mary Lou's parents, proud Americans in Washington D.C.

VII.

Mary Lou (Farino) Harker

My name is Mary Lou (Farino) Harker. I was the last-born in our house assisted by a midwife. I was the tenth of twelve children born to Italian parents who emigrated from Italy. We lived in Blue Island, Illinois. My father, Angelo Farino, was born September 29, 1888 and came to this country from Luco de Marcia (Rome) on the vessel *Stampalia* on August 22, 1912. (He renounced his allegiance to Victor Emmanuel III, King of Italy.) My mother, Maria Louisa Braccio was born October 8, 1898 and came to this country from Melfi, Potenza on October 5, 1916 on the ship *duke de ?* in steerage or third class.

As a child, my life was rich in Italian customs, Italian heritage, and wonderful food. Yet when I grew to be a teenager, I knew how different we were. Being raised in an affluent German neighborhood, instead of an Italian neighborhood, became a problem. They never heard of spaghetti or pizza. I craved their American food; peanut butter and jelly on American bread, meat and mashed potatoes, etc. were not our staples. We ate meat only twice a week. Saturday was Italian sausage or pork chops; we had chicken every Sunday and of course spaghetti. Some Sundays we had a roast for company. We had salad every single day and in the spring our salad was dandelions or tomato and onion salad with oregano. Of course, our spaghetti "gravy" was made with neck bones that at the time cost three cents a pound. This was during the Second World War. My mother took nothing out of a can. She put up all her own tomatoes, hot giardinara, eggplant, etc. We made our own wine and vinegar. She and my father grew a garden half-a-block long and it had everything we needed for food and health—tomatoes, peppers, lettuce, herbs, spices, and all kinds of fruit trees. She bought 100 pounds of flour at a time and made twelve loaves of bread every week in an outdoor "forno"(an adobe hut with a steel door, and a fire started with the "best wood scraps" from the lumberyard). We had homemade noodles, soups, stews, and pizza; and we thought we were poor.

When my mother baked those twelve loaves of bread every week, we always knew we would have pizza made in a square pan with fresh tomato sauce, fresh grated cheese, oregano (fresh from the garden), and homemade Italian sausage. She also made "fried dough," half with sugar for a sweet treat, and the other half plain for sandwiches filled with fried peppers or potatoes, onions and eggs or anything fried with an egg (*fritatta*). The last thing she made with the dough was an onion roll that was sliced like a jellyroll and fed the whole family.

Here, my mother prepares the spring ground for her half-long block garden.

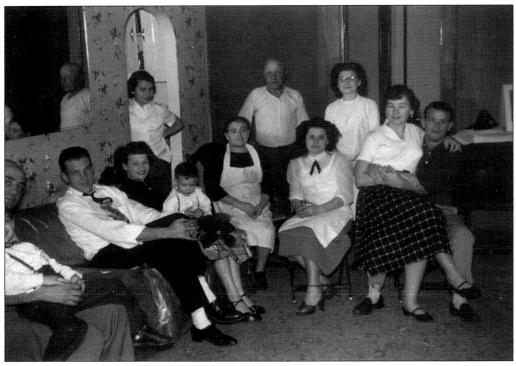

The "familia" after a Sunday dinner. This picture was taken for me. I was in Virginia (where my husband was stationed) and I missed home and all that good Italian cooking.

Sunday was "family day" and my three married sisters, Florence from Chicago and Esther and Rose from Chicago Heights, would come over along with their families for spaghetti at noon. After lunch we would clear the table and wash the dishes so we could get ready for the next meal at 6:00 p.m.; usually it was a roast, veal, pork, or mini-meat loaves and salad (*ensalada*). We ate until 8 p.m. It was the time for "familia," good conversation, and wine. The wine, "dago red," was homemade and came from our own wine barrels. When you reached twelve years of age you were welcome to try the wine. One day my mom said I was old enough to not only drink the wine, but I could now go into the basement and siphon the vinegar wine from the bottom of the vat. Half an hour went by and everybody was looking for Mary Lou. They found me—passed out on the basement floor. The "fumes" had knocked me out.

My memories of summertime are filled with images of the fruit my folks grew in the garden. We had strawberries, raspberries, pears, apples, and the most wonderful freestone peaches. On a hot day, when the peaches were ripe, they started oozing. The drops of nectar became like a rosary, one bead after the other, glistening in the sun. When the tomatoes were ripe and plentiful we would take our salt shakers and sit in the garden and eat them.

The first vegetables came around May when we had a salad of peppers, tomatoes, and onions with vinegar, oil, and oregano.

When the Italian feast of St. Donatus came, it was time for ravioli. My mother woke up at 4:00 a.m. and put five pounds of flour in the middle of her breadboard, made a well for the eggs and warm water along with four pounds of ricotta cheese, egg and fresh grated romano cheese and fresh chopped parsley with a little bit of sugar and proceeded to make 250 to 300 ravioli. She put a fresh doubled-up tablecloth on the bed and we kids had the task of laying those beautiful little "puffed pillows" gently on the cloth. They had to be turned after one hour and they took about four hours to dry. We couldn't wait for this

"Ma" and "Pa" are pictured here in the backyard with one of their grandsons. Notice the fruit orchard in the background.

Coming home from the "Feast of St. Donatus" mass, before our big ravioli dinner. Later at night, we went to the carnival where my mother packed a huge picnic basket of Italian goodies.

The Feast of St. Donatus, Blue Island, Illinois.

wonderful dinner. When they came to a boil we all wanted to "taste-test" to see if they were ready.

In the morning, before we had breakfast we went to church to see Saint Donatus with all the money pinned to him as he was carried through the streets. My mom always cried when she put the money on the saint; she had lost five children and three of her living children had afflictions. When the music started playing and the saint was lifted up, we all cried. It gave us the chills. Oh yes! It was a special day. There were only three times a year when my mother purchased new clothes for us: Christmas, Easter, and the feast of St. Donatus.

Then it was time to go to the "feast" of St. Donatus. Since we were very poor and couldn't afford to buy sandwiches, my mom would make sausage and pepper sandwiches and give us pieces of pizza. As we picnicked at the "feast," my father and I would split a dozen clams and my mom always let us buy "ceci peas," "pumpkinseeds," and "Italian lemonade."

My earliest recollection of my childhood was at Easter when I was about three or four. The Easter Bunny had brought us new linoleum for our floor. My sister, Esther, couldn't

Mary Lou, Margie, and Betty in their brand new Easter clothes. "Ma" always made sure we had on our best!

wait to show me. We didn't know what Easter baskets were, although, we did have hard cooked eggs and my mother always made an Easter salad with the eggs, oranges, and lemons with vinegar and oil, salt and pepper. My oldest sister, Florence, who worked in downtown Chicago, always brought the three youngest children a chocolate filled egg.

There were seven living children, one boy and six girls. I was the first one to graduate from high school. My oldest sister, Florence, had to quit school to go to work to help my mom pay the bills. She was my mother's helper at home, too. She was fourteen when I was born. I was a breech baby and my mother said the midwife was having a hard time getting me out. They thought I was going to die because the afterbirth came first. But my mother said she knew I'd be the strong one in the family and that has proven to be true. I have withstood all the deaths, sicknesses, and tragedies in our family and have remained strong. I became the "hub of the familia" after my mom's and dad's deaths.

I attended St. Benedict grade school in Blue Island and was a cheerleader during seventh and eighth grades. After World War II, the nuns (the school sisters of Notre Dame) gave us volleyballs and nets. I stayed after school every night to play volleyball. When the season was over, I would play football, baseball, and hockey with the boys. Yep! I was a "tomboy" and I never stayed in the house. I was outside playing every day until nine. When nine o'clock came around you had better be by that door or our "papa" would give us one as we were coming in late. Our Italian parents were strict and we kids were the better for it.

I have but one regret growing up Italian. I was ashamed of my parents because they were illiterate. My father signed his name with an "X" since he could neither read nor write. My

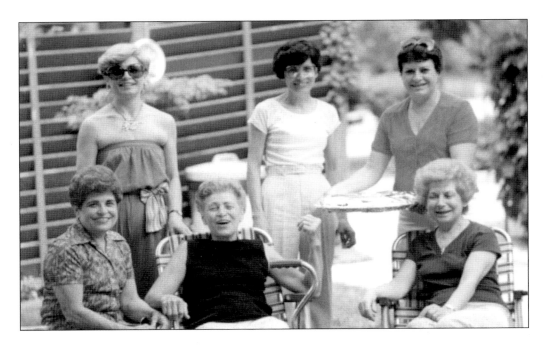

The Farino Sisters, pictured from left to right: (front row) Esther, Florence, and Rose (the three oldest); (back row) Margie, Betty, and Mary Lou (the three youngest. The only brother, Bob, took the photo at his home.

mother had gone to second grade in Italy and was taught sewing and how to sign her name in cursive. I had an inferiority complex and was so ashamed of my parents. I remember, once, when the PTA called and asked my mother to bring food for a church supper. She replied, "Mah sure, I bring-a the spaghetti and the meat-a-balls." I cried and wouldn't go to school for four days. The truant officer came to get me and I screamed and cried all the way to school. When Sister said, "Mary Louise, your mother's spaghetti and meatballs and Easter salad were the first food to go," I picked up my head and was so proud and yet so ashamed of myself for hurting my mom.

When I started high school, I made a vow that nobody was better than me and I was no better than anyone else. That helped me to feel better about myself and my heritage.

My mom and dad were so proud of me. Like I said before, I was the first of my family to graduate from high school. I became a cheerleader, baton twirler, and a member of the Girls' Athletic Club and Spanish Club. I did all my sports after school because I couldn't cross the gender line for boys' sports. I begged to be the kicker for the boys' football team; I asked if I could play tennis and longed to be on the baseball team. But the reply was, "those are boys' sports!" I cry now when I watch the Olympics because girls now have the chance to compete. My mom and dad couldn't afford to pay for lessons for anything. My father worked on the Rock Island Railroad and his paycheck was something like $37.50 a week. He was so proud of his job and thought he was doing a good job supporting his family but it was difficult on the wages he made. He claimed to have laid track from here to Nebraska, and later, through newsreels, we found this to be true and not a railroad "yarn." My mom had to take in boarders and started investing in property. With her signature only as collateral, my mom acquired three pieces of property. Later I became the

My father, Angelo, the "common railroad laborere." (Notice the tracks behind our house.)

Our home in Blue Island, Illinois. My mother decorated for Halloween and the local newspaper took this photo. She grew all those pumpkins and gourds (hanging in the trees). Pictured with my mother and father are the tenants that lived in the building my parents built next door.

sole owner of two of these and it has provided me with a trust to leave my children. My "little Italian mama" with her second grade education and signature did it all!

Neither my mom nor my dad could get their citizenship papers because they couldn't read or write and it was hard for them to memorize the required material. Their children were all born here in the U.S.A. and as undocumented residents they were able to reside here.

My high school years were the best years of my life. In 1950, General Eisenhower came

Mary Lou with her parents. They were proud to be Americans though they never received their citizenship papers. This photo was taken in Falls Church, Virginia. I was expecting my first child, Steven, who was born in Ft. Belvoir, Virginia, the same day Barbara Eisenhower gave birth to David Eisenhower, grandson of Dwight D. Eisenhower. My brother, Bob, drove straight through to Washington D.C. where my husband was stationed in Ft. Meyer, Virginia.

to dedicate our new campus building at 127th and Kedzie, Blue Island. I became part of the first graduating class of the new campus building later to be named Eisenhower High School. When I graduated in 1951, I cried. I loved school and didn't want to leave.

Because my mother knew how to sew, (thanks to her second grade lessons) I was the envy of the high school girls. Every morning for a week, my mother made me a broomstick skirt. I had a matching headband and sometimes a tie for my blouse. I'd wear the set one-day and my sisters Margie and Betty would wait a week and then wear it to their class. We were the youngest three in our family; the four older children had married.

I met my husband, Elmore J. Harker Jr. during my last year of high school and married him while he was in the army during the Korean conflict. We were married at Ft. Devens, Massachusetts. And we ended up living in Falls Church, Virginia for two and one half years while he was stationed at Fort Meyer, Arlington Halls, Virginia, and later at the Pentagon in the National Security Agency.

My husband worshipped my parents and they absolutely loved him of course, because he played the accordion and had a movie camera. My mother was his best fan and actress.

My husband, born to English and Polish parents married into this beautiful Italian family and our children Steven B. Harker, Michele (Harker) Martin, Kristen (Harker) Zint, and their children: Michael and Matthew Mueller, Brianne and Daniel Harker, and Tyler and Justin Zint now own this beautiful " Italian heritage". Viva Italia!

Michele (Harker) Martin made her debut and bowed before Archbishop Cody in 1976. Her escort, Russell Abbate, is shown below, at right, the year before.

A young deb has her moment in the spotlight at the Italian Heritage Ball. In a celebration of the Italian family, the proud mothers of the debs are escorted to the ball.

Debs take a bow for the Italian family

Louise Farino's relatives in Italy. The person behind the donkey in the middle is my Aunt Theresa. She visited my grandma (seated, second from the right) and encouraged her to come to America.

Louise and Angelo Farino at a wedding in downtown Chicago in Hotel Shoreland's "Louis XVI" room. This photo was put on porcelain and attached to their monument in St. Benedict Cemetery, Crestwood, where they are buried.

Recipes

Mary Lou (Farino) Harker

ITALIAN RAVIOLI

Dough:
5 lbs. flour
10 eggs
2 Tbsp. butter (melted)
5 tsp. salt
2 1/2 cups of warm water

Filling:
4 lbs. Ricotta cheese
2/3 cups of parsley
1 tsp. sugar
3/4 cups of Romano cheese (grated)
6 eggs
salt and pepper to taste

1. *Pour flour on board or table top, making a well in the flour. Place all dough ingredients in the well. Slowly work sides of flour with the ingredients. Mix well and knead until smooth. Place in a bowl, cover, and let stand for half an hour.*
2. *Mix all ingredients for filing and set aside.*
3. *Cut dough into 4 workable pieces. Roll out on a floured board or floured table top. Each piece should be about 1/8 inch thick or about 36 inches around. Starting 2 inches from the edge of the dough, place 1/2 teaspoon of filling, 1 inch apart in a row; one row at a time. Fold over the 2 inches of dough, covering each mound of filling. Gently press with fingers in between each mound.*
4. *Using a drinking glass, cut each mound out by pressing and twisting the glass around the mound. Press each ravioli with fingertips to seal edges. Generously dust each ravioli with flour and place on absorbent surface to dry.*
5. *After about 1 hour, turn over to dry other side. Never place sides touching to dry. Allow about 2 hours for drying to freeze, but 3 to 4 hours if using the same day.*
6. *After drying about 2 hours, ravioli may be placed between sheets of Saran Wrap in a container used for freezing.*
7. *Ravioli are easier to handle and boil better when frozen. When boiling ravioli, add a teaspoon of oil to water to prevent them from sticking together. The pot for boiling them must be big enough to allow expansion. Boil for 20 to 30 minutes, turning gently with a wooden spoon.*
8. *Drain in a colander and place in a large shallow platter.*
9. *Sprinkle freshly grated Romano cheese on top. Spoon on your favorite Italian sauce, covering all ravioli. Turn gently and repeat with cheese and sauce.*
10. *Bon Appetite! And Ciao!*

Makes approximately 200 ravioli.

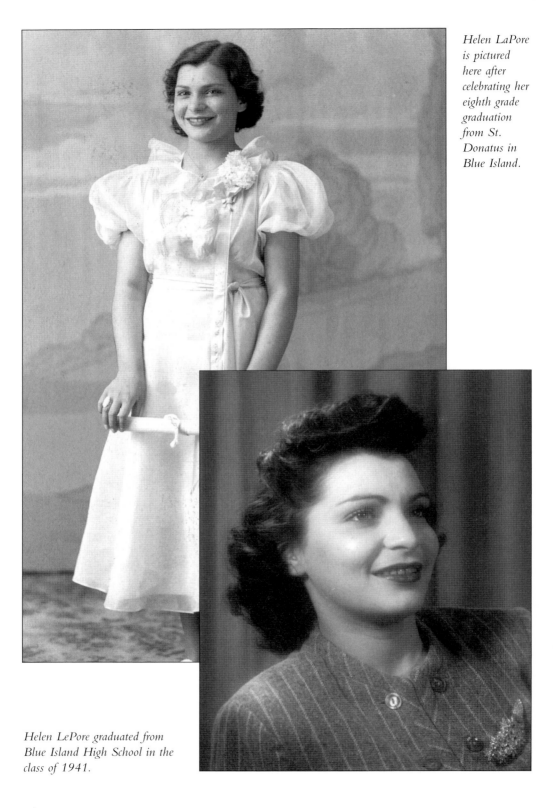

Helen LaPore is pictured here after celebrating her eighth grade graduation from St. Donatus in Blue Island.

Helen LePore graduated from Blue Island High School in the class of 1941.

VIII.

Helen LePore Fry

Michael LePore was born in Ripicandida, Italy on June 12, 1853. He married Maria Rosa Robino and they had three children, Antonio, Rosemarie, and Michele.

My father, Michele, came to the United States at the age of 14, stayed for awhile, and then returned to Italy. At the age of 17, he returned to the United States and lived with his sister Rosemarie in Altoona, Pennsylvania. Can you imagine what courage it took for a teenager who knew no English to face a long journey on a ship and then to seek employment? It took real guts!

My dad worked as a laborer for the Pennsylvania Railroad. From what I hear, they were expected to work very hard and were even pushed around. This was difficult because prior to this, my dad had not worked a day in his life.

By the age of 25, my dad had saved enough money to send for Rosa Leopaldi, his fiancée. They were married in Mt. Carmel church in Altoona, Pennsylvania on April 23, 1911. They continued to live with Aunt Rosemarie and her family, Antoinette, Lucy, and Pat.

When my mom became pregnant, dad wanted the best of care for her so he sent her back to Italy to stay with his father's family until the baby was born. My mother told me she was treated like a queen and her every need was taken care of. They sewed her clothes, washed her hair, and saw that she had the best possible food. Since my mom's family lived nearby, she couldn't have had better care.

Can you imagine how excited Grandpa Rocco and Grandma Madeline were when baby Anthony was born? He was the first and only child they were privileged to see and they made the most of it. Anthony and my mom remained in Italy during World War I and since my dad was concerned about the outcome of the war and whether or not his wife and child would be allowed to return to the U.S., he made plans to go to Italy and bring them back with him.

When Anthony (Uppy) was 3 1/2 years old, they sadly left Italy and began the arduous journey back to the U.S. The trip was very scary with bomb threats, sirens, children crying, and fear of disease. During the whole trip they had to wear lifejackets that were very confining and uncomfortable.

Imagine how happy they were to land on Ellis Island and see the Statue of Liberty. My father told me over and over again, "I'll never go back; I'll never go back." Mom said the same thing and she kept her word until she was 86 years old and took an extended tour of Italy.

I don't recall what year, but my mother, father, and Uppy moved to Blue Island, Illinois and rented a house on Fulton Street owned by Santinicola. My dad and family lived on the second floor while the owners lived on the first floor.

My dad got a job with the Illinois Central Railroad and went to night school to learn to read and write English. Later he worked himself up to tool and die maker in the Burnside Shops. He was considering retirement but when the company learned of this, they provided him with a helper who would do most of the hard work. My dad was even allowed to take naps, which shows how much they valued his work.

Eventually my dad retired and called his daughter Madeline to help him fill all the forms. He received a Railroad Retirement Pension which he had paid into and also his Social Security check. When he filled out the forms, he chose the lesser amount so my mom would get more if something happened to him. My dad also had to decide if my mom should take her portion now, since she was 64. She decided not to.

The day they got their checks my mother was very excited. When Madeline called at noon my mom said, "I haven't worked a day in my life but I am going to get a check monthly." So dad went to the bank, cashed both checks and gave my mother all her money to spend as she pleased. Instead she put it in a savings account since she had all she needed.

Helen Fry on graduation day.

Mother Rosa Leopaldi, and father Michael A. LePore

When my parents moved to Blue Island, there was no Italian Catholic Church. The Italians got together and invited a priest to say Sunday mass in Martino's grocery store, facing 127th Street. Eventually they built a small church on the corner of Division and Oak. They had decided to name it Madonna of Mount Carmel but later decided on St. Donato of Ripicondida.

My father was one of the founders of the Feast of St. Donatus. He went from house to house to collect money to pay for a band and purchase lumber to build stands for refreshments etc. He was president of the St. Donatus Society for many years and also held the office of Secretary and Treasurer until 1964. He proudly marched in the St. Donatus procession as long as he was able. He died in 1979 at the age of 79.

I, Helen LePore Fry, was born in Blue Island in 1923. I was one of five children; the others are Anthony, James, Madeline, and Eda. We went to St. Donatus Grade School and Blue Island High School. I went to Chicago Vocational School for my business degree.

My first job was at Merrill Lynch, Fenner and Blane at the Board of Trade. Later, I did merchandising for Frank's Dept. Store in Oak Lawn. I retired from work in 1976.

On Easter Sunday of 1945, I met Richard Louis Fry who was on leave from the Navy. We had a great time together until he had to return to his base in Washington State. He fought in all the major battles of WWII and survived.

On June 15, 1946, we were married in St. Donatus Rectory followed by a reception at my parent's home. We went to Starved Rock for our honeymoon and stayed at the Lodge. The

scenery was beautiful and we have gone back there many times to visit.

In 1947, Carol was born and was followed by Richard in 1952. My grandchildren from Carol's family are Leslie, Eric, and Chris. Richard's children are Bradley and Justin. I am so very proud of my five grandchildren.

You can imagine how proud I am to claim my four great-grandchildren; Evie, Josh, Jessie Rose, and Jayden. It fills my heart with joy to see them growing and prospering. There is no joy greater than being a great-grandmother.

My life has been intertwined with airplanes. First, because my husband built and flew planes and secondly, because I was also a pilot. In 1964 Dick built a Midget Mustang. Then he built a

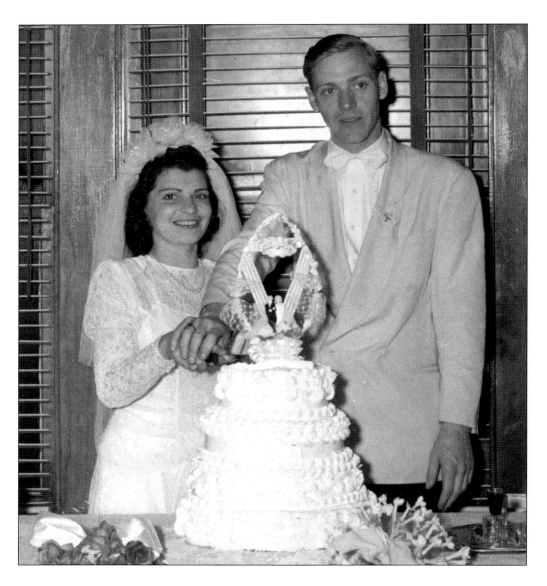

Helen LePore and husband Richard L. Fry.

Bearcat (1/2 scale) which he donated to the Elburn Museum. Next he built a Bearcat airplane (3/4 scale) which he has not completed as yet. He is working on it at the Morris Illinois Airport. At Lewis Airport, he and Chapter 15 members are building a V Star which is almost completed.

The plane I flew was a factory built Comanche Aircraft and I enjoyed going places in it. I no longer fly but I still enjoy my plane trips. The only other plane we had was a home-built Davis. I called it Batman's plane. It was never one of my favorites.

My life as an Italian American has been very fulfilling and exciting. What a wonder it is to reflect on my ancestors and their achievements. What a blessing it has been to have such a great life in such a welcoming country. America is the best; I am so happy to be a part of it.

Helen LePore Fry preparing to board her Midget Mustang plane for a relaxing trip.

Richard Louis Fry stands next to his plane, a Midget Mustang.

Virginia F. Seriani Cook as a young girl in Chicago.

IX.

Virginia F. Seriani Cook

In 1897, Georgia Battaglia married George Iacono and they soon had five children. Unfortunately, of the four boys and one girl, only Giovanna survived.

When Jennie (Giovanna) was five years old, the family returned to Santa Cruce in Italy so George could fight in WWI. Since they had to survive, Georgia and Jennie began a poultry business, selling chickens and rabbits.

In 1919, when the war ended and George returned, he decided the family should go back to America. Georgia told him they couldn't go because of the business. George took care of that by going into the street and enlisting the help of the people he met there. He told them they could have as many free chickens and rabbits as they had children. The people of that small town were delighted and soon the poultry cages were empty. Then George told his wife and child, "We are no longer in business. Now we can go back to America."

The trip to America began as they boarded a ship to Ellis Island. The trip was long and many people became ill, including Georgia. However, George and Jennie felt great and were able to eat the many chocolate delicacies offered. This was the beginning of their lifelong love of chocolate.

In 1920, George and his family settled in Chicago. The fact that they both had relatives living there made their lives a lot easier. However, it was not easy to find work. George finally used his friend's labor card and was hired as a laborer at the site of the First National Bank of Chicago. This proved to be very unfortunate. It had rained the night before and while working, George was killed by a mud slide. His friend lost two legs but survived.

Since Jennie was only 12 years old and the family had no insurance, Georgia decided to start a grocery business. Even though she could not read or write English, she supported her family for 58 years. This was quite an accomplishment for a person with so little education.

Once the Iacono family was on its feet, Georgia began the Italian tradition of the St. Joseph's table. The first boy that passed her place of business became Jesus, the first woman became Mary, and the first man became Joseph. They were special guests at the table filled with traditional Italian foods. Fish and pasta dishes abounded and Italian pastries completed the festive meal. The neighbors looked forward to the St. Joseph's table each year.

On April 22, 1922, Jennie Iacono married Jacob Seriani. They had two boys and four girls, Marian, Frank, Virginia, George, and twins, Kay Marie and Karen Ann. All the children married and had loving families. We children carried on the Italian traditions, especially when naming our own children.

I married John E. Cook on June 1, 1972. We lived in a garden apartment in Evergreen Park, Illinois for two years. Then we moved to an apartment on Ninety-third Street. Our son, Kevin Jacob Cook, was born and became the apple of our eyes.

I had several jobs. I worked for Illinois Bell Telephone Company as a long-distance operator for 22 years. When Kevin was born, I wanted to stay home and take care of him. And as soon as he was enrolled in school I became a Crossing Guard. This fascinated me so much that I worked there for 18 years and continue to work as a Crossing Guard to this day.

As a part-time job I worked at Menu-Mart in Evergreen Park. I made salads and enjoyed the time I could spend with co-workers and customers. I retired in January of 2002.

I am so very proud to be an American of Italian descent. Italian traditions are important to me and being able to understand the language excites me. As a member of the Italian-American Women's Club I can socialize with others who feel as I do. I am so very proud of my ancestry.

The 50th Anniversary of Jennie Iacono Seriani and her husband Jacob. Virginia Seriani Cook and her husband John Cook celebrate with them.

Francine Lanzillotti's wedding to Charles Lazzara in January of 1987. From left to right are the bride's mother Rosemary, new husband Charles, dad Joseph, and sister Angela.

Francine Lanzillotti Lazzara

My paternal great-grandparents were Carmine Lanzillotti, born in Calabria, Italy, and Mary Parente, born in Basilicata, Italy. In 1890, they married and came to the U.S. and raised three children, Mary, Christine, and Anthony.

My grandfather Anthony was a liquor salesman and married my grandmother Angeline in 1925. They raised three children, and much to the delight of all the relatives, this included a set of identical twins, Carmen and Joseph. Joseph, my father, has been mistaken for his brother all his life. Even at the age of 74 this happens often, leading to many humorous situations.

My maternal grandparents, Pasquale Di Pasquale and Philomena Tomasso, were born in Abruzza, Italy and married there. In 1895, they came to the U.S. and raised four children, Rufus, Terry, Assunta, and Frank. My grandfather Frank married Rose Caruso and was the first Pasquale ancestor to be born in the U.S. and also the first to graduate from high school.

Grandma Rose lived to the age of 95 and was the last of the nine children in her family. The Pasquale family had three children, Frank, David, and my mother Rosemary. Rosemary married Joseph Lanzillotti who was elected Mayor of Berwyn and served from 1981—1993.

My mom, Rosemary Lanzillotti, was a very successful and active Italian-American woman of whom I am very proud. At the age of 21 she worked for Eastern Airlines as a Flight Attendant. After five years she could no longer work there because she was married and wanted to start a family. My mother was also a tour guide at O'Hare and worked for United Express at Meigs Field as a Customer Service Representative. She also was a Quality Control Representative for Midway Airlines.

In 1978, she founded the Ladies Auxiliary of the Italian-American Civic Organization of Berwyn. She also held the position of Recording Secretary and continues to serve in that capacity.

My sister Angela and I were born and raised in Berwyn, Illinois. We both went to Montessori (early years), St. Leonard's Grade School, and Nazareth Academy for High School.

In 1981, I attended St. Ambrose University in Davenport, Iowa and received my degree in Political Science. This was the same college my father graduated from in 1950.

After college I worked for two years and then married Charles Lazzara from Evergreen

Park, Illinois. I continued working until the birth of our first child, Taylor Ann, in 1988. Julian Joseph was born in 1990 and this was a thrill for my father because, as is true of all Italian men, it was important to have a male in the family. My father can't bear to miss a single sports event if Julian is a part of it.

When Julian was in kindergarten, I began my working career. From my first job as a part-time merchandiser to my current employment as a consultant manager for an upscale lingerie line, Le Mystere, I continue to be an area representative in the Chicago area.

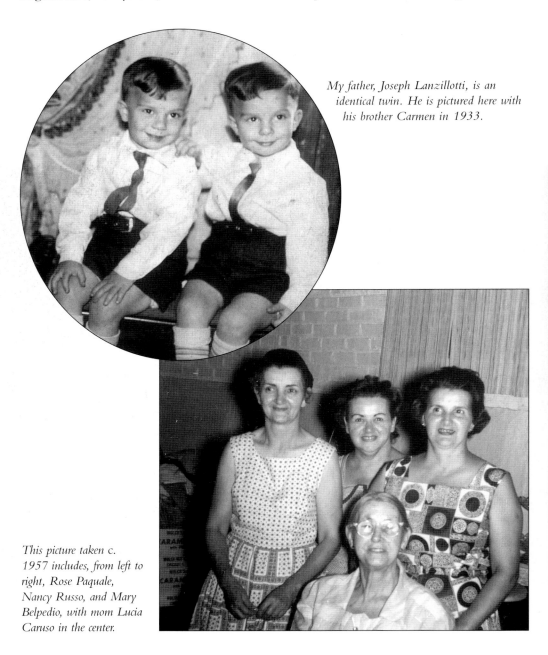

My father, Joseph Lanzillotti, is an identical twin. He is pictured here with his brother Carmen in 1933.

This picture taken c. 1957 includes, from left to right, Rose Paquale, Nancy Russo, and Mary Belpedio, with mom Lucia Caruso in the center.

However, my job takes me to many far away places. Some of my more frequent trips are to New York, Texas, and Minnesota. In the year 2000, I was honored by my former company, Chantelle, as Consultant of the Year. This award allowed me to visit Paris for a week. The most memorable moments were seeing the Mona Lisa at the Louvre and the Eiffel Tower. The food was good and the wines were great. I enjoyed every minute of my trip because the French made the meals a social event, just as we Italians do.

Growing up in Berwyn, I thought everyone was Italian. Our Sundays always started with church followed by a luscious meal. We could always count on many relatives enjoying the pasta and gravy, meatballs and neck bones. Our salads were the typical vinegar and olive oil and we always had to have garlic bread. Homemade desserts, especially cookies and *pizzeles* ended our festive meal. Homemade red wines were an integral part of our festivity and the card game Kalukee ended our day.

Growing up Italian with loving parents was an experience I will always cherish. There was no need to even discuss self-esteem because I always knew I was loved and felt I was special. To be Italian meant taking pride in my family and in my heritage. I wouldn't change that for the world.

This wedding photo features my paternal grandparents, Angeline Storto and Anthony Lanzillotti. It was taken in 1925.

Marijo Doody is pictured here in her college graduation photo. She graduated from Mundelein College in 1958.

XI.

Marijo Doody

I, Marijo Doody, am the daughter of an Italian mother and an Irish father. I was the oldest child of the three that were born. The second child was a boy, Jimmy, who died at the age of 15 months. The third was a girl called Betty Ann.

I was born prematurely at 7 months and consequently was in the hospital until after thanksgiving 1936. Early in life, I had a deficiency in the eyes due to early birth. I wore glasses as an infant. As a young child with glasses, I was teased and taunted, by the children. I attended two grammar schools—St Columbanus and St. Francis de Paula.

After grammar school, I went on to Aquinas High School. This was an all girls' Catholic high school. I took college prep courses—Latin, literature, math, and science. I also took typing as my mother said my penmanship was not readable and if I were to go to college, I would need typing for class assignments. I remember that I did not do very well in typing, as it was right before lunch. This was later attributed to hypoglycemia. In high school, I was active in the chorus. I believe the Italian music was the reason.

I graduated and went on to Mundelein College. I commuted to the North Side. Teddy, our dog, would walk me to the bus stop and wait with me until I got on the bus. After, he would go home. Mundelein was an all girls' college for liberal arts and sciences. During my freshman year I took a general course with an idea of a major in chemistry. I had courses in math, religion, Spanish, gym, and other electives. I took Spanish as Italian was not offered. Some of the words were similar. I did find out I had no language aptitude. I also was in the singing music club. I could always sing harmony and was needed. Some of my friends were in music so that it was nice to partake in their original programs. I had chemistry labs in the afternoon and I would sneak out of the lab with my gray lab coat and apron up one flight of stairs to the music floor. (Needless to say, the coat and apron were removed for singing.) I was fortunate my lab partner never told I was out of the lab. The teacher never found out until after I graduated. In second year, I continued the chemistry program with more courses and electives.

At the end of second year I entered the religious order BVM's. I was in Dubuque, Iowa for several months. I was very sick as I had to eat all sorts of things that I hadn't before. Particularly sweet things as early in life I discovered that they made me sick. At that time, I did not know why. I was asked to leave for sickness. In 1960, it was identified as

Hereditary Fructose Intolerance by a team of Medical Doctors at the University of Illinois. They published their findings in *The New England Journal of Medicine*.

I returned home and went back to Mundelein. It was the beginning of second semester junior year. I remember coming back and walking around the school for several minutes. I felt that I was a failure. I will always remember going into the auditorium and a music student was playing organ. That was most comforting.

As a second semester junior in chemistry, I could not take the chemistry courses as they started in September. I took second semester American literature and other electives. In summer school, I picked up added courses for senior year. I was still active in music while at Mundelein. I also was involved in the Loyola Opera Society. We were in *Aida*, *The Force of Destiny*, and *The Masked Ball*. The Italian Opera wetted my appetite for more things like that. I will always remember the Verdi "Requiem" that we did in the chapel in Loyola. Once at the Chicago Symphony, as they were playing and singing that requiem, I was conducting in the seat and was hit over the head with a program.

In senior year, I had double chemistry courses to have the requirements for graduation, so I had organic and physical chemistry along with other electives. We had nine chemistry majors in my graduating class. Two girls went to medical school and became doctors. Two went into the medical technological fields. I went into industry after graduation.

I will always remember graduation, as I was the first in the family to graduate from college. My father's three sisters, Sally, Mary, and Bernice were present and it turned out, Aunt Byrd was in school with one of my religious sister chemistry professors. To this day 45+ years later, they still ask about each other.

My first job as a chemist was at the University of Chicago La Rabida Institute. It was an interesting period, as women were not accepted in university cycles. I was hired as a clinical analytical chemist. As I look back, I am grateful that they hired me. The doctors, all MDs, were working on connective tissue disorders. This was an eye opening experience there. It was an all-male medical environment. Here I was a woman, so honored to be the first at the University Chicago's La Rabida research department. There were days when being a gentile, woman, and Christian evoked different feelings. At times, I felt that I was out-numbered.

I remember fondly a female, Dr. Yelva Lynfield, a dermatologist. She did her skin work research with our department and I did analytical work for her. Her husband, Joshua, was also a doctor, working at that time at Cook County. After ten years, he was the first doctor to do open heart surgery on a newborn child. That was in 1967 and he was cited all over the world. We had great times with religious and political discussions in the late 1950s.

When the job moved from the campus to the cite near the sanatorium, I was told that one could not socialize with the med tech people on the hospital staff and the research group was segregated. It was a very lonely working environment. I left the job and went into industry at Nalco Chemical.

My aunt and uncle knew the human resources person at Nalco, so that was how I got in. I joined the analytical water analysis department. An African-American man, Terry, and I joined the company the same day. We were both token employees at that time. We lived on South Shore at that time, so I car-pooled with other employees in the area.

As a woman at Nalco, I had to punch a time clock even though I was classified professional. Then all women punched the time clock. The men in the same class did not. At that time, Nalco was in the Clearing Industrial District off Sixty-Fifth Street southwest. Sixty-Fifth Street was not paved then and at the first rain/snow it was a mud hole. Traffic did not go very fast. Consequently, I punched in when I arrived as the rules stated. When

it was time for a raise review, I was told, "you were late x times"; "you are not the bread winner of the family". It was not an equal opportunity environment. However, those were the times, and women scientists did what they had to.

The work was sometimes dangerous. I remember I was put on a project where the previous chemist died from cyanide poisoning. The company's business was water treatment including boilers, where hydrogen cyanide is used. We received samples for analysis. I was always running outside to clear my lungs. Those days, 1959-1964, there was no OSHA (Occupational Safety and Health Administration).

During that time, I took my first trip to Italy in 1960. My mother wrote to relatives in the farm country from the addresses on Easter and Christmas cards. When the group arrived in Milan, I was paged in the dining room as Maria Josephina Doody. I was not used to hearing my name in Italian, so the friends convinced me to investigate at the front desk. Low and behold, there was a cousin on my mother's side with the name Emilia Giacomelli. Her grandfather was the second cousin to my mother and aunt.

Needless to say, it was a grand meeting even though I do not speak Italian and she knew no English. One of the parties traveling in the group spoke Italian, and she translated that evening as we walked all over Milan. Emilia told me she was a seamstress and would be

In this photo from the 1980s, Marijo Doody, the chemist, is hard at work.

married in a year. Other relatives were going to meet me in Florence. I remember giving her a compact with a ten dollar bill as a keepsake. After twenty years, she still had the compact and ten dollar bill. In Florence, I met cousins who spoke Spanish; another person in the group acted as translator and we used three languages. In addition, while I was in Italy, I met personnel from Nalco's Italian branch. It certainly was a memorable trip.

I left Nalco and went to Armour Dial as an analytical chemist. During this time, I became active professionally in the Women Chemist group and the Society of Cosmetic Chemists. Armour Dial was the soap company; the work was interesting and challenging. I was in charge of competitive product analysis. At that time, I had three technicians working for me. I vividly remember that it was twenty years after I left the company that I actually had to buy soap for home use. At that company, I had a chance to branch into evaluations and microbiology along with some analytical instrumentation. After four years, the company was moving to Phoenix Arizona. I chose not to go as I was a single lady and my family was in the Chicago area.

My career path moved on to Enterprise Paint Manufacturing Company. I was hired as the Detergent Chemist in research and development in the Janitorial Supply division of Federal Varnish. In the research lab, we had four chemists and a group leader. There was a floor polish specialist, a solvent chemist, a varnish applications chemist, and I was the detergent chemist. It was a fun place in the beginning. As a development person one took the idea to completion in production.

I was active in the Chicago Association of Technological Societies (CATS) and was Program Chairman and President. I chaired two successful programs on "Careers in Science and Technology" at the Museum of Science and Industry. Proceedings were videoed and published in several engineering publications co-authored by the Museum Education Department and myself behalf of the CATS.

During this time, I was a regular subscriber to the opera and eventually symphony. The vice-president of research was a music lover, but not baroque, so whenever that was the program at Chicago Symphony, he would call me up for a very important meeting for his tickets. I also was fortunate that Lyric's administrator was the sister of another of the vice-presidents, and at times I was able to obtain hard to get opera tickets.

In 1980, while planning a vacation, we decided to go to Italy as we had had contact with the daughter of Emilia, who wanted to pen pal to practice English. We booked the trip that took us from Rome, Capri, Sorrento, and ended in the Lake District, Stresa. In Rome, contact was made with Loradonna and her father and they met us at the trip's end. We had three days of life in the Italian farm country and it was wonderful for mother to discover her roots. Loradonna indicated that she would like to visit us in America when school was completed.

While at Enterprise I held a number of positions, including chemist, microbiologist, paint chemist, quality control chemist, and analytical chemist. When another paint manufacturer purchased the company many people lost jobs. They made all sorts of changes. That was during the time my mother was very sick.

Loradonna visited us for several weeks and mom was able to relive the Italian heritage. It was good for me also as I was able to take Lorry around Chicago and meet family and friends. My Irish cousins really enjoyed Lorry, as they were close in age.

The Janitorial Division and my job were going to be moving to the new paint plant in Wheeling, Illinois. It was 45 miles away. At lunch, I was going home to change oxygen tanks for mom. There was no family leave program at that time.

This was in August 1984 when the move was recorded for the following January. It

This photo shows St. Anthony Chapel and altar for the familia Grotti and Giacomelli in modena Italia. It is located on farm land in Northern Italy. The photo was taken in 1980.

Marijo Doody in the Chemistry lab at Old Plant/Lab cite in Chicago.

turned out management had miscalculated production and capitol output at the Wheeling site. They needed more production at that site. They thus planned to move the janitorial division's production and technical staff the following January.

Mom passed away in September that year and I told management I could now go to Wheeling. They informed me my job would be eliminated at the year's end. Later that year as I was not emotionally ready for a career move, the manager of quality control invited me into her department as they were trying to upgrade. This was good and bad. I was at a stable environment; there was no cut in pay. I had to punch a time clock, but would get overtime pay.

Lorry came back for a short visit and brought a Blessed Mother statue for my mothers' grave. She wanted her to have something from Italy at the grave. We glued the statue and for over five years, it was in tact. It eventually weathered away.

In 1988, while working in the lab with one of the research fellows, I heard a loud pop. We went on a quick walk and found the plant on fire. We pulled the alarm and alerted all to get out. While we were outside the plant, the foreman was trying to see if all had gotten out. One person was missing. With the fire out, the safety personnel went back in and got the man came out with help. He was burned over 95 percent of his body. He died the next day. His wife worked with me and collapsed in my arms. When I went back into the building to get my coat to go home, the fireman said "How can anyone work here it is so toxic?".

The following business day on a Monday, management's attitude was so awful that one began thinking about the career path again. It was the common man who paid tribute to the fallen worker. I began thinking about the generation of peoples I had known from the company and how not very many lived long enough to cash a retirement check. It did not matter where they worked: office, lab, or plant. After two months, the lady whose husband died in the fire was given an ultimatum to return to work or lose her job. The boss said to me he was putting her in my day spot and switching me to nights.

The first day I was on nights there were two gang- related knifings in the area. The next day I went to a recruiter and put an updated resume in for a chemist position. I was contacted immediately for an interview in Melrose Park, which I felt went very well. A few days later, I received a call for the job offer, which was satisfactory for salary and job classification. I turned in a resignation letter giving two weeks notice at Enterprise. I had been with the company 20 years. They were shocked. It turned out to be a good move as a few years later there were very few people left.

I joined the Alberto Culver Company division Masury Columbia Janitorial Supply. It was in Melrose Park, Illinois. I was hired as a senior chemist. I was only able to stay in Melrose Park for six months as the parent company spun off the division to get capitol for another acquisition. I had to again rethink my career path. The good thing was that I had received added background in janitorial supply products and was more equipped for higher responsibility.

I had been receiving calls from Hysan Corporation. I called and set up a meeting for an interview. I indicated that my present position was moving out of state and I was not interested in relocation. I joined Hyson as a senior chemist. Much more computer work was involved as the technological world was changing. I became quite proficient in the word processing areas. My high school typing finally paid off. We were in research and development. This included testing, regulatory, labeling, and start-up production. There was a team of five chemists each in specific and overlapping areas.

The work was interesting and challenging; however, the management had severe problems

and after four years, three of the chemists got layoff notices—including myself.

During this time, I would get letters from Lorry giving the updates on the Italy front. She was going to be married. Then there was no word for a couple of years. We eventually heard from her. In 1990, I went to Italy for her wedding. She was married in the church her grandfather helped to build. The sir name of my mother was in the churches' cornerstone.

After the Hyson' layoff, the four to five weeks I was out of work was the first time I did not have a job since I was 21 and out of college. It was Advent and I remember lighting the candle at home and praying "send me some light!" Shortly after, I made a phone call to the wife of a former colleague who had died. Her comment was, "We were just talking about you, Marijo, that we could use someone with your qualifications." However, they said I was with a competitor. I told them I was laid off and was looking for work as a chemist.

After she contacted her son, Bob, the president, I went for an interview. At the interview, Bob showed me his father's file phone numbers and after my old business card was "she is a great person, hire her." After a breakfast meeting with the two owners, I joined them as the technical director.

As the technical director I was a one man show with all technical aspects: research and development of products, quality control and assurance, Regulatory affairs, (Federal and States), Material Safety Data Sheets, Technical Data Sheets, production scale up, and records. In addition, I was technical service to salesmen and customers.

When they hired me, there would be lots of computer work as the president was young and very perceptive in computers. They were happy with what I gave them over a nine year period. As the wearer of many hats as Technical Director, a satisfying career path closed on my 65th birthday as I was retired and replaced by a young 32 year old Ph.D. chemist. He

had new computer aptitude that I did not. I had a successful career for 44 years and wanted to do different things with life, such as travel. For my retirement, I received new golf clubs. They work well. They had a party for family, friends, and the working people.

Over the many years of life, I have dabbled in music in several singing groups, both secular and religious. I have gone to the opera over the years and have enjoyed in particular the Italian operas. This seed was planted at home in an Italian mother's house with an Irish father who liked music. I can remember when I first started working and got a Lyric subscription for myself and one for my mom and dad. My mother would get so mad at my father's rattling candy wrappers while the music was playing. None of his people could understand why he liked opera.

My career path was published in the *Iotian,* a women's professional quarterly periodical. I was inducted into the Chicago Academy of Technology as a charter member and I am included in *Who's Who in Business & Professional Women*. I co-authored articles in "Careers in Science and Technology" in engineering periodicals. This was from proceedings at the Chicago Museum of Science and Industry, Chicago Association Seminars in the late 1980s.

I held several professional officer positions in Iota Sigma Phi, Society of Cosmetic Chemists, and The Chicago Association of Technological Society.

I had a fulfilling career for these times in history that I was a pioneer as a scientist. While being a chemist, I never stopped dabbling in music.

I, Marijo Doody, am the product of an Irish-Italian merger. I am a retired a career chemist after 44 years. As a person, I am a daughter, sister, Godmother, aunt, cousin, colleague, and friend to many people.

Written by Marijo Doody
11-6-02

Josephine Catherine Giacomelli Doody

(1905–1984)

by Marijo Doody

In 1905, my mother Josephine, an Italian American, was born in South Wilmington, Illinois. Her parents emigrated from the town of Fanano in northern Italy. This was significant because the famous Italian singer Pavoratti came from the same area.

Josie never knew her mother, Olimpia Grotti, because she died in childbirth in 1907. However, she knew her father, my Grandpa Jack, who had a big smile and a red beard.

There are many stories of his adventures as a coal miner in the strip mines; he said he crawled on his belly in underground caves. On December 7, 1941, Grandpa Jack died, the same day as Pearl Harbor. His death may be attributed to his inability to arrive at the hospital on time since few people owned cars. One of my best memories of him was when we would work in his garden as he taught me Italian.

Grandma Josie had a high regard for education. This was due to the extreme poverty of her early school years. In first grade she was sent to school without paper or pencils. She also had no shoes. Naturally, she was not allowed to remain in school until she had the necessary supplies.

When grandma died, my mom and her sister Marie were sent to live with a neighbor who had many children. After several years, when they were 9 and 11 years old, they were sent to work on a farm. They both received an eighth grade diploma but their schooling stopped for awhile.

When Josie was 17, she left Wilmington to go to Chicago. She had a lot of self-confidence and began to work in a restaurant while attending high school at night. Her brief bout of TB slowed her down but not for long.

After completing high school Josie began to study to be a cosmetician. My prize possession is Josie's State of Illinois Apprentice Beauty Culturist registration card, 1931.

Two of Josie's most famous clients were Mrs. Al Capone and Mrs. McSwigin. One story I remember was that Mrs. Capone put a hanky into Josie's hand and told her it contained $500,000 worth of diamonds. Josie asked her not to ever do that again since she did not care to know anything about where her husband got his money. After that incident, the yellow Capone car was sent regularly to pick up Josie to fix Mrs. Capone's hair. She even trusted Josie enough to lend her a coat. In some of the most beautiful pictures of Josie, she is wearing Mrs. Al Capone's coat.

The girls in my family were dancers and often went to the Aragon and Trianon ballrooms. It was there that Josie met a dashing young man, Jim Doody. Their friendship blossomed and in 1936, the day after Valentine's Day, they were married.

Josie now became a part of a large Irish family of three sisters-in-law and eight brothers-in-law. Jim's father, fire Chief Doody, especially loved Josie because as she was meeting Jim's family she asked if his father was his older brother.

Josie was a very talented housekeeper. She could sew and do needle work and was also

Josephine Giacomelli is pictured here as a young woman in her 20s. This photo was taken c. 1925.

an excellent cook and baker. Since her husband was a tradesman, he wasn't home very much. He also spent a lot of time at the firehouse with his father, Chief Doody, or visiting his many family members.

Being a part of an Irish family took its toll on her. The only Italian Josie had contact with was her sister Marie. They only spoke Italian when they did not want their conversation known.

In September of 1936, I was born prematurely. Since I had to remain in the hospital until Thanksgiving so I could achieve a weight of five pounds, they baptized me in the hospital. My baptismal name was Mary Josephine, but they called me Marijo. The party in my honor had to be held without me.

In 1938, a son, Jimmy, was born. When he died at 15 months of crib death, Josie was accused of killing him. However, she was tried and exonerated. In 1961, it was determined Jimmy died of Hereditary Fructose Intolerance (HFI). The findings were published in the

Grandma Josephine Doody is pictured here with her granddaughter, Jenny Duffy. This photo was taken in the early 1980s.

New England Journal of Medicine by University of Illinois professors and doctors.

I am a survivor of Hereditary Fructose Intolerance. As a child I could not eat fruit, ice cream, or desserts since they made me sick. Instead I would eat a peanut butter sandwich. My mother would cook soups with rice and spinach or pasta dishes that I could eat.

My mother was very protective of me as a child. Since I wore thick glasses with a black patch over one eye, the school children would make fun of me. In first grade a boy kicked me and I was in a bad accident. My mother was always there to soothe my hurts.

A milestone was reached when the family moved to their first house at 7804 Kimbark in Chatham. At this time we also got a dog, Teddy. He was a golden retriever and lived for 16 years. Teddy saved the life of a neighbor child by alerting everyone about the overturned carriage. He also saved my father's life when he came home with an appendix attack and was out cold on the porch. Teddy kept him warm in the below freezing weather until he was discovered.

When I was in eighth grade my father had a terrible burn accident. He was covered with gauze and fishnet because he suffered third degree burns. He needed hospital care and skin grafting to recover. However, he was never the same after that. He needed medication for his severe pain and was unable to work.

Since there was no Workmen's Compensation, a tradesman who couldn't work received no pay. In order to earn money Josie once again began to rely on her beauty practice. She did this at home to keep poverty at bay.

When I graduated from college, it became my responsibility to help support the family. After my sister Betty married at the age of 21, mom, dad, and I moved into a home in

Josephine and Marijo Doody are pictured below in Fanano, Italy in front of Josephine's mothers home. The home was stone with a thatched roof and a modena and child porcelain.

Evergreen Park, Illinois. There we were able to live a very prayerful and faith-filled life. We were also able to go to the opera in Chicago. Music and prayer were very much a part of our lives because of the Italian influence. It had always been Josie's dream to have both her daughters earn college degrees and have successful careers. This became a reality when Betty completed her degree in education and I became a degreed chemist. Betty taught for over 30 years and I worked as a chemist for 44 years. So Josie, the young girl with no shoes or pencils, became a success in her own right.

Josie's last eight years of life were spent traveling. We went to California, Hawaii, and northern Italy. After arriving in Rome, we placed a call to my cousin Lora Donna Merelli who lived in Milano. We met in Strassa and spent some time talking over old times. Of special interest was a mix-up over land rights. After much discussion it was discovered that the postmistress had confiscated the papers that should have been sent. Thus a 35 year rift was settled and the family was once again at peace.

Josephine Giacomelli Doody and Jim Doody in the late 1960s. James passed away in 1975.

Josie and I toured the area and met relatives from both sides of the family. We visited my grandparents' home, the family chapel and local cemetery. It was wonderful to immerse ourselves in the Italian atmosphere and reestablish our Italian roots.

Josie died in September of 1984. When my cousin Lorry returned to the U.S., she brought a statue of the Blessed Mother for her grave so she could have something Italian. Unfortunately, after five years the statue disappeared and was never seen again. She was a loving person who was tolerant, talented, creative, and spiritual. I salute you, Josephine Catherine Giacomelli Doody. You were truly a great Italian-American woman.

International Who's Who of Professional Management

is proud to welcome...

Ms. Marijo Doody

...as one of their newest members.

Members of the International Who's Who of Professional Management organization have met the requirements established by its Board of Directors as well as satisfying the necessary criteria for inclusion in the annual membership directory.

President and Chief Executive Officer

Marijo Doody was a successful career woman at a time when women struggled to be accepted as professionals. Her first job in 1958 was at the University of Chicago in clinical chemistry. After one year she left to go into industry and spent the next five years at Nalco Chemical Company. Her career continued as an analytical chemist and supervisor at Armour Dial for four years. At this time she became active professionally in the Women Chemist Group and the Society of Chemists.

Marijo then joined the Enterprise Paint Manufacturing Company and held a number of positions; microbiologist, quality control, and paint analytical chemist. She was also active in the Chicago Association of Technological Societies and Program Chair and President. She chaired two very successful "Careers in Science and Technology" at the Museum of Science and Industry in Chicago. The proceedings were published in several engineering publications.

Marijo was honored by the Chicago Academy of Technologies in 1984. She was listed in *Who's Who in Science and Technology* in the early 1990s. Her career path was published in the *Lota Sigma Phi* quarterly periodical. Over the years, Marijo has pursued an interest in music and been a part of several music groups, both secular and religious. Her love for the opera has its roots in her Italian ancestry. To love music is to be Italian.

Being Italian has always been a source of pride for Marijo. Being Italian American was even more important because she loves America so much.

Recipes

The Doody Family

SPAGHETTI SAUCE
Josephine Giacormelli Doody

1. *Sauté onion, mushroom, and garlic. Add chicken and pork pieces and brown in the usual manner. (Beef can also be used.)*
2. *Add 1 can tomato paste and several cans water to cover meats. Bring to boil and reduce heat to slow cook.*
3. *Cook for 2-3 hours. Season with salt, pepper, and dash of oregano.*
4. *Cook any pasta in the usual manner. Drain.*
5. *Serve with sauce and gently toss to all pasta covered. Add conventional cheese to suit taste.*
6. *This sauce can be served with rice (cook rice in sauce), polenta, eggplant or other veggies.*

DOODY POTATO SOUP

1. *Make light chicken broth (if want flavor) or cook pealed type potatoes, onion, celery, spinach, and rice.*
2. *Add garlic and parsley and any other spices for flavoring.*
3. *Cook several hours.*
4. *A ham bone can be added for flavor.*
5. *Serve hot as a meal or before an entrée.*

Mary Lou Apicella Gorka as a young girl.

XII.

Mary Lou Apicella Gorka

My name is Mary Lou Apicella Gorka and I am very proud of my loving, caring, and hard working Italian family.

My mother, Catherine Lovero Apicella was born in 1909 in Bari, Italy in the town of Montorne Adelphia. Her father, Marco Lovero, was born in 1889 in Bari and came to America in his early-20s to look for work and a home for his family. He was a barber by trade and found an apartment behind a barber shop where they could live and he would work. He then sent for his wife, my grandmother, Maria Louisa DiVirgilio Lovero who was born in Bari, Italy in 1890, and their two children, my mother, Catherine, who was three years old, and my Uncle Pete, who was two years old. They came to Ellis Island and then traveled on to the north side of Chicago where they lived on Hoyne and Huron Street. My grandparents had five other children in America, giving them a family of seven children. My grandmother was never able to go to school in Italy and my grandfather had only three years of grammar school. But they were both very intelligent people. My grandmother died when she was 62 years old from diabetes. Her mother, my great grandmother, lived to be 99 years old. My grandfather lived to be 95 years old. His father, my great grandfather, lived to be 100 years old.

My grandfather was a wonderful cook. He took over the cooking when grandma died. My mother and my aunts helped out when we all got together. We would have seven course dinners and we would eat for hours. Everyone looked forward to seeing each other and eating these wonderful dinners.

My father, Thomas Apicella, was born in Chicago in 1908, the oldest of six children. His mother, Concetta Caputo Apicella, was born in Naples, Italy in 1886 and his father, Alphonso Apicella, was born there in 1880. Their dream was to come to America and they did shortly after they were married. My grandmother was 21 years old and my grandfather was 27 years old when they came to America in 1907. They came to the south side of Chicago and later bought a home on Twenty-Fifth and Wallace Streets. The neighborhood at that time was primarily German and Irish and my father said that he would get "beat up" quite often because he was Italian and not welcomed in that neighborhood. When they first came to America, things were hard for them financially and my dad remembered when they used to eat onion sandwiches because food was scarce. I remember the vegetable

garden in the backyard and the baby chickens being raised in the garage. I remember the rag man, the ice man, the coal man, and even the man who sharpened knives. My dad was only able to go to school until the fifth grade because he had to work to help his family. He had one job selling nuts on the streets.

My mother, Catherine, met my father, Thomas, at Dearborn Glass Company in Chicago where they both worked. They fell in love, but my mother's father would not hear of it, so they eloped when my mother was 18 and my father was 19 years old. My mother had her first child, my brother Alphonso, in the days of the Depression and things were pretty hard for them. They couldn't afford to go to a hospital, so my mother had her baby at home. He was a big baby and it was a difficult delivery. Later on, because they couldn't afford much heat, my brother's hand almost froze while he was sleeping and he came down with pneumonia. Those were hard days for my parents. But things got better and they went on to have my sister, Connie, myself, Mary Louise, and my younger brother, Thomas.

We had a very good childhood with loving and caring parents. My father started his own business with my Uncle Al as his partner. They owned and managed the Archer Glass and Mirror Company on Twenty-Sixth and Normal Streets for 40 years.

During wartime air raid drills, my father was an air raid captain. He was an active member of the Knights of Columbus and also became a Fourth Knighter. My mother was a wonderful cook. There would be days when she would make over 200 ravioli for company. We would all help her. My Aunt Millie was great at rolling the dough out with a rolling pin as long as a yardstick. My dad had a vegetable garden and grew the biggest tomatoes ever. He received recognition in the newspaper because of his huge tomatoes. My mother made the best spaghetti sauce in town using my dad's home grown tomatoes.

Catherine Lovero Apicella.

My mother used to can them and many other fruits and vegetables. My mother also made the best pies. Her pie crust melted in your mouth. My parents worked so hard I sometimes wonder how they did it.

My mother started a hope chest for me and my sister, which she gave to us when we got married. This was an Italian tradition and it was very important for my parents to follow this custom. To be an Italian meant to follow tradition.

The family of Mary Lou Apiclla Gorka, husband Stan Gorka and children, Kathleen, Mark, and David.

Loretta DePaul as she graduated from the eighth grade.

XIII.

LaVerne DePaul White

My Memories

MY MOTHER, LORETTA MAGLIANO DEPAUL
(1906–1965)
b. Chicago, IL USA

My mom knew how to make a party. Everyone would turn and smile with joy when Loretta would arrive wearing a fashionable dress and the latest style hat. Her hats were all different and were perfectly coordinated. All of the guests and friends would join her as she mingled with the young and old. She was a personable, friendly individual who would burst into song at a moment's notice singing American, Irish, and Italian songs.

My mother and I were very, very close. My mother had the charm and sensitivity of her mother, Concetta. She was a sickly, delicate child. Loretta was musically and linguistically inclined. She spoke good Italian at home and learned to speak German at St. George Catholic School. She was given piano lessons by the nuns and was permitted to practice in the convent during the Sisters' lunch hour. One day Loretta was practicing the song, "Beautiful Ohio" in waltz time. She got carried away and started jazzing it up and playing it in Rag Time. The music teaching nun was so embarrassed before her peers that she refused to teach Loretta piano any longer. So Loretta studied the keys on our player piano in the parlor and taught herself.

Each year the school featured two school plays. Loretta was always selected to be the star in these German language productions for the Parish. Monsignor Springmeyer praised Loretta publicly before the German speaking audience for her impeccable pronunciation. At the age of 14, she became deathly sick with pleurisy and pneumonia. The illness lasted for three years. Because of this illness, Loretta was unable to use the scholarship she had earned to St. Scholastica High School in Rogers Park.

When she was 17, she married Frank DePaul. She had two daughters, Rosemary and Laverne, and twin sons, Frank and Conrad. Rosemary at the tender age of 14 months died of an enlarged congenital heart. I was born on January 12, 1927. Conrad and Frank were born on July 14, 1930. On the day they were born, the *Daily News* was giving away a counter washing machine to mothers of twins born that day.

My high school years (1945+) launched a new era of fun when parties were created to

Loretta and LaVerne DePaul, and Roe Fumo in 1950.

bring the next generation into the adult world. This continued for Frank and Conrad and our cousins during their high school and college days. As young adults, we always felt a significant part of their adult world. Parties were outstanding events filled with fun, song, and dancing. Our young people's parties never separated the young from the old. We all mixed and had fun together.

During the Depression, mom used to invite all of our friends into the house on Sunday for a jam session as she played the piano and sang old and new songs for us. She would feed beggars when they came to our door.

I especially remember the Melrose Park Italian Feast Picnics. My dad would drive the South Side relatives in his truck. Judge Louis Senese, my grandmother's cousin, presided over the picnic and carnival festivities. Loretta was also president of the Sons and Daughters of Oliveto Citra, Italy.

MY AUNT ROSE MAGLIANO FUMO
(1909–)
b. Chicago, IL USA

Aunt Rose Fumo is the only sister of Loretta Magliano DePaul. Since Loretta was always so sick, Rose filled the void in the household by taking care of the family. She has always been known as the matriarch of our family. As of this year, 2002, Rose is still going strong at 93 years of age. She is the oldest surviving member of the Magliano family and has become the backbone of our family.

Rose has always been dependable and hard working. Whether it was keeping the books for her husband, Joseph's Reliable Tailoring Company or teaching her grandchildren the art of Italian cooking, you could always count on Rose. Her desire to share her talents with others has made Rose the catalyst of our family. She has spent weekends at my home,

cooking and sewing for my family. Even at 93, Rose still ministers to her family and extended family through her hardworking presence in our lives. She is a woman of great stamina.

Rose is also a woman of character. Whenever we were sick or down, Aunt Rose was always there with a word of encouragement and hope. During my brother Conrad's long illness with kidney disease, Rose was always there with a listening ear and a compassionate shoulder to cry on. Conrad has since died and Aunt Rose now bears the cross of caring for her ailing son Mike, who also suffers with kidney disease. Through all these trials, however, Rose always keeps a joyful spirit within her. She brings fun and a youthful spirit wherever she goes. In my youth, some of my happiest days were spent shopping and designing hats with Aunt Rose. In my golden years, I still look forward to the times spent with Aunt Rose on the phone or during visits.

MY GRANDMOTHER, CONCETTA DIVITO MAGLIANO
(1880–1942)
b. Oliveto Citra, Naples Italy

My grandmother was a good natured, beautiful woman. She was very caring. People considered her "Mrs. Congeniality" with a personality plus. She was the peace maker of the family and would stand for no gossip. She always had a kind word for people. She acquired many friends that would come to her for advice. When my grandparents bought a four flat, my grandmother was the chief painter for all the apartments. She would also paint the outside, with my Uncle Charley painting the high areas. When the water pipes would freeze, Grandma would crawl under the dirt foundation with a torch and thaw out the pipes.

Grandma Concetta had many nieces. When the girls became of dating age, my grandmother was the match-maker. When the fathers of the girls were frugal and would not indulge, she would argue with the men, "Do you want your daughters to marry? They must look presentable to find a spouse!" The fathers would reluctantly give in and the girls would be deeply appreciative of their Aunt Jack-a-Jack. She acquired this name from Tony Sarro, her nephew, because when they were young, they couldn't say "Zia Conchetta," but instead said, "Jack-a-Jack."

MY GREAT-GRANDMOTHER, MAMA ROSE SENESE DIVITO
(1849–1939)
b. Oliveto Citra, Italy

My great-grandmother, Mama Rose DiVito, was a humble, good, and very religious person. In her spare time, she would always be fingering her beads, saying the Rosary. She became a widow in her twenties and had three daughters—Sylvina, Sarafino, and my grandmother, Concetta. Her husband Francisco came to America to become a citizen and pave the way to send for his family. While working here he drowned. Mama Rosa's brother, Louis Senese, sent her the means for her and her family to come to America. Upon my grandmother's marriage, she lived with Concetta most of her life, occasionally staying with the other two daughters. It was a very hard life for her because she never remarried. She helped raise Concetta's eight children, which wasn't easy. She sacrificed a lot.

Rose Catigula DePaul
(1864–1927)
b. Teggiano, Salerno Italy
As told by Bernice Angone Bates

Recollections of sayings from my Mom and Dad and other various relatives, about Grandma DePaul:

She waited seven years to marry her French Legion Soldier, Conrad (Cono) DePaul. She was left a young widow with four girls and two boys to support. She was a very strong lady, but then I guess she had to be. Her husband, Grandpa DePaul, was a typical Frenchman who was very laid back.

It was very hard for widows at that time to make any type of living and there was no social security or help to get. I guess at first she took in laundry and did ironing for people. I know my dad gave her financial help when she came to help my mom with the kids because my mom had to work in my dad's store. Grandma cried every time my mom said she was going to have another child because it meant so much more work. My father's boyhood friend became the Mayor of Chicago (Mayor Kelley) and he used to call Grandma DePaul "Mrs. Real Estate," for she really had an eye for buildings. With the Depression on, I guess she could not do too much with it. Mayor Kelley used to have his office call her for homes that were going because of back taxes. Being that the mayor was Irish, he really loved Grandma DePaul's Italian cooking.

When grandma was getting old and sickly, she told my brother, Ray, that before she died, she wanted to see Buckingham Fountain; Ray took her to see it. This made her so happy that she talked about it for days. My grandma and her family attended a friend's wedding where my Aunt Pena and the accordion player seemed to take a liking to one another. He asked my grandmother if he could see Aunt Pena, but grandma told Aunt Pena not to bother with him for he probably would not do too well in life just going around playing for parties and weddings—that man turned out to be Petrillo—who headed the Chicago Concert Band and Musicians Association. So as good as she was with buildings, she was not as good at picking husbands. My Aunt Pena never made her forget that. After all, she encouraged her to marry "Frenchy." When my Aunt Katie died and left Rose and Joe Rulo, my Grandmother DePaul raised the two kids until she passed away.

Recipes

RISOTTO (TOSCANA STYLE)
Mary DePaul

Diced chicken livers and giblets
1 clove garlic
1 onion
1 cup celery
1 cup parsley
1 cup uncooked rice
1 cup dry white wine
3 cups chicken stock
salt and pepper
1 cup grated Parmesan cheese
1 cup margarine
1 tsp. saffron, pinch of nutmeg (optional)

1. Saute chicken giblets and livers (diced) in margarine or oil, add onion, garlic, celery, parsley, add wine until absorbed and onion is soft.
2. Add rice and cook about ten minutes, stirring constantly—add one cup stock and mix well and continue stirring and adding more stock.
3. Cook over low heat until rice is cooked, about 15 minutes, add half of the Parmesan cheese and cook another 20 minutes—stir in more stock if needed.
4. Just before serving, add the rest of the Parmesan cheese.
5. Use wooden spoon to stir.

Chicken livers may be omitted. You may use diced pork and veal, or just diced chicken pieces for the meat.

STUFFED ITALIAN BUNS
LaVerne White

12 Italian buns
1 1/2 lbs. of ground beef
1 onion chopped fine
1 can Hunts Tomato sauce
1 can mushrooms
1 can chopped black olives—optional
1/2 lb. grated Parmesan cheese

1. Brown meat and onion, tomato sauce, mushrooms for 15 minutes.
2. Open top of pan—pull out bread, fill with filling and wrap in foil.
3. Freeze.
4. Bake approximately 40 minutes if frozen, 30 minutes if not frozen.

LaVerne DePaul in the sixth grade, at seven years old in 1934. The bench that LaVerne is sitting on is an heirloom that she still owns.

XIV.

Ce Ce White

Memories of My Mom

My mom was the original "Supermom!" Before that phrase was coined in the 1980s, my mom was already working full time, raising a family, going to night school, volunteering at church, and carting us kids to all of our events. Now don't get me wrong, my father was very active in our lives as well, but my mom's work schedule was a little more flexible being a teacher, and she took advantage of those extra few minutes in a day. Nevertheless, it meant a lot to me that in the midst of her busy schedule, she never sacrificed me for one of her other obligations.

I can remember when I was in the sixth grade and my Girl Scout Troop needed a leader. I never imagined my mother to be a likely candidate for the job, but she took on that commitment! While my old Scout Leader, Mrs. Sink, was a very fun and adventurous outdoors woman, my mom brought a more "corporate" approach to the job. I remember her organizing all the moms who had any hobbies to share with our troop. For weeks, these moms taught us how to do many crafts like macramé and ceramics. In the end, I was a richer person for the experience, having learned so much and bringing so many samples from my learning experience home. My mom also perceived that our troop could earn a trip to Washington D.C. by selling Amway products. This brainstorm was to her advantage as well since she and my father were Amway representatives at the time. Unfortunately, selling door to door and holding an Amway sale at our church didn't help us raise enough money for D.C., but it was a fun experience nonetheless.

My mother instilled in us hard work and the value of a clean home. Each day had its own regiment of chores—cleaning the bathroom and the kitchen. My mom hates a dirty sink! The weekly routine consisted of dusting, vacuuming, scrubbing floors, and doing laundry. We also had to wash walls and wash down all the furniture twice a year. Do you think our brother, the only boy in the family, was excluded from these chores? Think again; even though there were three girls to handle the daily and weekly chores, my brother Jim had his share of duties as well. During those "slave years" we each would bicker about how hard mom was working us. I know today we are better people because of her pushing.

Kolanda DePaul, Lori Spaugh, Anne Monique Egan, Julie Davidson, LaVerne White, CeCe White, and Brett Davidson, 2001 Christmas.

My focus has been on the "work ethic" that my mother has instilled in us. I cannot leave without mentioning the strong commitment to family my mother stressed in our lives. Today my parents celebrate 45 years of marriage. Those years have not always been smooth sailing, but both of them have stuck it out through thick and thin. They have demonstrated in their marriage a great faith in God. They have brought important decisions to God in prayer and have trusted in our Lord to provide for the family during the "lean years."

My Italian mother has also demonstrated a strong desire to keep family together. Growing up in this household, I knew my second cousins and my third cousins and probably some cousins 25 times removed. My mom was close friends with her brothers and many of her cousins. We knew through these intimate friendships that we could call upon any number of our family for help and support. Unfortunately, many of that generation have died and my generation has not done a very good job in keeping up with each other. Hopefully however, as my mom's generation is no longer alive to keep the "glue between the family," one of we younger ones will pick up the torch to carry on.

In the midst of our formative years, I know my mom worked like a dog, but at 75 years of age, I know she can now look back with satisfaction at all the wonderful ways she has changed this world for the better. Through her education, she has grown in her gift of teaching. Through teaching she has touched the lives of thousands of children. Through church ministry, she has brought Jesus' love to hundreds of people. And through her role as wife and mother, she has established a house with a foundation of rock, one that will not sink in the midst of a storm of adversity.

Thank you, Mom for all that you have taught me!

White family portrait. Pictured, from top left, clockwise, are CeCe White–teacher, Lori Spaugh–paralegal, Jackie Davidson–mother and house manager, Jim White–vice-president of Alcatel, LaVerne–retired teacher, and Joe–husband and retired engineer.

Three generations of the DePaul, Frederick, and Candrevo women.

DePaul Epilogue
by LaVerne DePaul

Loretta DePaul was an amazingly gifted woman. Her life experiences were the prototype of America. The ethnic, racial, and economic blending of all its diverse new citizens replicate, in a sense, what Italy was to the Greco-Roman Mediterranean known civilized world of ancient times.

This reality came to a peak when Loretta and Frank celebrated their 40th wedding anniversary at Martinique Restaurant, Niney-Fifth and Western, on August 30, 1964.

Although they planned the event, the families and friends enjoyed a surprise blending of musical tributes. From Frank and Yolanda came the Gulino Family expressions of tribute. At the head table their brother-in-law "Doc," Angie Florenzo's husband, created a styrofoam display of Loretta playing her baby grand piano with replicas of Conrad, Frank, Yolanda, LaVerne, Joe, and their three grandchildren singing. A ruby money tree from one of the other families along with artistic-tributes poised and displayed on the head table. The Gulino Family performed musical tributes one after another, spanning the events of their 40 years. Their Irish friends from the St. Sabinas' Lateran Club performed Irish songs from past DePaul parties hosted over the last 15 years with Loretta's musical mixes and honky-tonk piano style. German songs from Loretta's early grammar school days at St. George's School were performed in impeccable German. The cream was a medley of Italian love songs. The banjo music of their Beverly "Rainbow Ice Cream" owner added to the Gulino girls'—Marie, Gloria, and Anita—combo. Their Polish brother-in-law Albert Kosiek did his "Umbriago" Act. Each table of guests prepared their own musical tribute to Frank and Loretta.

The priest, Father Francis Kamp, SVD gave a special tribute at the benediction, a collage of family pictures. Loretta performed a musical thank you. Marie Fosco played the accordion for Mom's song specialties, "McNamara's Band," "LaSpanola" in Italian, and "Ach Die Lieber Augustine" in German.

Yet the many tributes from this myriad of cultures all came to fruition in an American sing-a-long songfest of WWI, Depression, and WWII-era music, which Loretta led.

Yes, Italians are a cross-section of cultures from everywhere. They rarely are clannish because the known civilizations of 2,000 years have blended bloodlines into their very cultural dynamics as a nation. Our family was always proud to be American first. This is the legacy which their descendants continue to pass down. Thank you Loretta! You were and still are a "gift" to our family, even today in the 21st century.

ROSE GAMBONE GULINO
c. 1890 to 1955
by Frank DePaul
B: New Kensington, Penn.
M: Joseph Gulino 1905
D: Chicago, IL 7-26-55

A very strong young lady, 15 years old, lived with her father in a small Pennsylvania town north of Pittsburgh, Pennsylvania. She had a brother who became a psychiatrist and moved to Ohio. She lost her mother at an early age. Her only brother received a higher education and relocated to Ohio. Her father and she had a boarding house and became blessed when a young, handsome Italian musician came to live there sometime at the turn of the century. Giuseppi Gulino was ten years older. His story is an Italian and American love story.

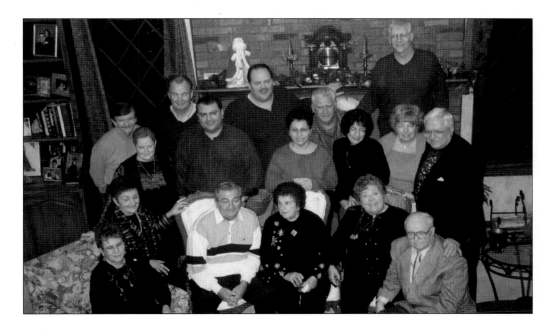

Celebrating 2001 Christmas with Rose Fumo. The Fumos, Maglianos, DePauls, and Whites.

The Gulino Sisters; Anita, Gloria, Yolanda, Angie, and Marie.

Rose married Joseph at age 16 and together they began a family of seven wonderful children: Arthur (1906), Biaggio (1908), Marie (1911), Angeline (1916), Anita (1919), Gloria (1923), and Yolanda (1933). Six of the children were born in New Kensington, Pennsylvania and lived in the same home on Walnut Street until 1929 when the family "up'd" and moved to Chicago, Illinois to the Wicker Park area on Cortez and Damen Streets.

Their youngest, Yolanda Clarice, was born on August 5, 1933, the year of Chicago's Great Century of Progress! She was a delightful surprise, reared in a home of eight adults, who helped Mother Gulino nurture this little girl with love. She is a blessing to the Gulino family. You see, she became my wife on August 11, 1962 and the mother of our children, William Francis (1-10-66) and Anne Monique (5-3-69). Let's go back to where the story began.

Giuseppi Gulino was born in Vittoria, Sicily in 1880. His father was a cobbler by trade and a musician by avocation. His son was going to fulfill his unmet desire to become a professional musician from the day Giuseppi burst into life on this Sicilian Isle of Many Cultures. For more than two thousand years, Sicily had been the crossroad for Mediterranean civilizations.

Over the centuries, Sicily was strategically located. Hence, the Greeks, the Romans, the Turkish, the Carthaginian, and Norman Conquests created a blending that is Sicilian. Giuseppi's family was no exception. You see the name Gulino was probably originally

The new Magliano, DePaul-White, and Fumos with our 93 year old Aunt Rose Magliano Fumo, Christmas 2001.

French (Gelineau), and his mother's maiden name was Mole. The period of his birth was the aftermath of the Unification of Italy which was begun by Victor Emanuel from the north and Garibaldi from the south. There were 21 independent countries among this Italian peninsula of the "Boot." Sicily was the one with the most blending of cultures. The multiplicity of conquests left the island rich with talent. In a great sense, the Gulino family of Chicago, Illinois represents a blending of cultures that our world is still experiencing today.

You cannot tell the story of Italian-American Women without telling the story of the male/female blending of the Italian family. The Gulino's are the quintessential expression of the best of the Italian family. Giuseppi had two sisters, Concettina and Mole, who emigrated from Italy to Chicago. His brother was an immigrant who became an evangelist minister as a result of his American experience. That family located in Southern California. They kept somewhat in touch over the 20th century. It was through Giuseppi that their father's musical dreams became reality.

At an early age, the Mandolin was his father's main instrument of leisure. His parents determined to send him to school and create an educated dimension that previously was not possible before the unification of Italy. It was easy to unify and create Italy, but difficult to make 21 states to become Italian.

Sicilians are unique. They were trespassers who always remained isolated creators of

multi-faceted blends of the Mediterranean. The Gulino's Italianized their name, probably because the Norman/Napoleon French conquests were seen as intrusive.

Giuseppi's education and musical development was easy. He had perfect pitch and mastered instruments of music quite easily. In his youth he performed with the town band in the park square and even in the town's only premier concert hall. His father was determined to send him to Palermo, to the Conservatory of Music. Upon completion Giuseppi went to Milan to eventually become a musician in La Scala's famed orchestra. Leaving home was easy because of his talents. He had work during the opera season, but needed work over the summer, so he worked as a musician sailing on vessels between the old and new worlds. His travels most certainly included Buenos Aires, where a heavy Italian emigration was occurring, and New York, which also had a large Italian population. During the last of his voyages, he decided that America would be his choice. So he passed up Ellis Island and literally "jumped" ship. He moved to the New Kensington, Pennsylvania area where he knew some of his kinsmen were located. There, he met and married Rose, created a music business teaching the town's young, and became the town's "Music Man." His success was evident as the town folk enjoyed his summer concerts in the park and sent their children for music lessons.

He included his only two sons, Arthur and Biagio (Buzzy), in the band. Arthur and Buzzy went on to the Pittsburgh Conservatory of Music in their late teens while Marie, Angie, Anita, and Gloria became female versions of his love of music.

Rose was the heart and soul of Joseph's success in New Kensington. She hosted afternoon teas for the ladies and prompted the children's growth in age, wisdom, talent, and grace. Their Catholic faith was the on going thread that kept the family united. Her boys returned from the Pittsburgh Music Conservatory; they needed to get musical jobs. In the late-1920s, Pittsburgh did not have enough work.

Rose and Joe decided to send Arthur and Buzzy to Chicago to visit Aunt Mole (Concettina) in the Wicker Park area. There were plenty of musical work opportunities there. When the boys came home and told of their adventure and success possibilities they said "We're moving to Chicago."

"Wow!" Rose told Joe. "No way are we breaking up this family! If they go, we all go." So Joe retired as the town's Music Man, they sold their home, and relocated to Aunt Mole's Chicago neighborhood. There Joe purchased a "Banker's" two story home with an English basement studio and enrolled his daughters in the Columbus Public School on Augusta Boulevard. The time was 1929. The boys were employed in many orchestras and had many musical job opportunities. The Great Depression happened, but Joe's home was paid for. However, income and family needs dictated he set up a studio in the English basement. He resumed teaching all the musical instruments. With his financial successes he invested in two more buildings for income and taught his girls piano and their instrument of preference—Marie, piano/accordion; Angie, mandolin; Anita, percussion; and baby Gloria, piano/accordion. By 1933's World's Fair, his daughter Marie formed an all-girls orchestra called The Rhythm Flappers. They performed in the Spanish Pavilion. In the meantime, Arthur, the Violinist, played with the Cesar Patrillo Orchestra on the Radio, Florian Zabach Orchestra at the LaSalle Hotel and for 25 years was the first violinist at the Ivanhoe Dinner Restaurant. Buzzy played in many local orchestras. The orchestra known as the "Krazy Klowns" became national and wanted Buzzy to travel. He had a family now and declined. Instead he freelanced and played in the local vaudeville/burlesque orchestras prevalent in the 1930s and 40s. Marie became an entrepreneur and musical performer.

Turning her piano expertise toward the piano/accordion was as easy as the transition to

The Gulino Family in travelling band uniforms in Pennsylvania.

banquets, private parties, and business entertainment, where she strolled and sang at cocktail party events. Every year the Illinois Central Railroad took their employees to Mardi Gras in New Orleans on their train. Marie was their steady music woman. She met her musician husband, Don Fosco, and together they continued making music. Anita and Gloria formed a combo during World War II and played at Spike and Pickles in Bridgeport. There they met their spouses and retired to motherhood and family.

The World War II-era was a trying time for our nation. Gloria's husband to be, Albert Kosiek enlisted prior to their courting, but they exchanged correspondence. Al became a hero in General Patton's Army in Austria when, as leader of 23 men, he liberated two German Concentration Camps on May 3, 1945 near Linz, Austria. On that date his 20 page letter to his mom described the unfolding of his intuitive initiatives that would liberate more than 5,000 prisoners. In 1970, he was invited by the government of Austria to the dedication of those liberations. He was overwhelmed by the survivors calling him "their liberator." He returned home. In 1975, for the 30th Anniversary he returned with Gloria and discovered new friends. They travelled to several homes on their journey homeward in Luxembourg, France, and Belgium.

During World War II, we united behind our nation. In fact Anita, Gloria, and their cousin Mary Mole wrote their own song for their departing soldier clientele at Spike and Pickles. "Don't Leave Me Now" became their theme song. It is a marvelous patriotic love song.

Rose Gulino was at the heart of her family. She kept family together throughout these Depression, war, and post war years by her entertaining at holiday meals. All the families'

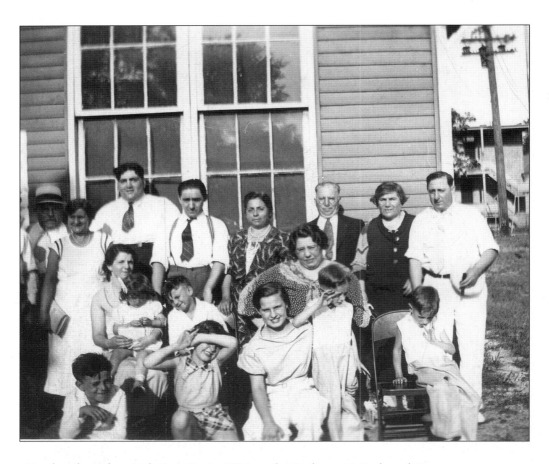

Attending the Melrose Park Festivities in 1939 are the Maglianos, DePauls, and Fumos.

Opposite: *Gloria Kosiek and Anita Hinder Gulino.*

in-laws and out-laws filled their home on Thanksgiving, Christmas, and Easter. In the summers, she prepared a weekly Sunday picnic at Humboldt Park on "Bunker" Hill for all of their friends, family, and relatives to come to. And come, they did!

Yolanda, born August 5, 1933, was a joy to this family. The love of music was poured into her, but she was determined to become a teacher and attend college. Her name was given by Rose because the Italian Princess Yolanda came to the Century of Progress as a follow-up to Balboa's aerial Italian squadron landing ceremoniously on what is now known as Balboa Drive. Yolanda's sister Angeline married Algerino Florenzo from Steubenville, Ohio. They lived upstairs in one of the two apartments divided for Marie and Don (and little Donnie) and Al and Angie. They are the only Gulinos not blessed with children. Yolanda became their special child. Al was a college educated naprapath and Angie was a beautician at Marshall Fields. They guided and counseled Yolanda by implanting in her mind that education includes a college degree. She graduated from the Chicago Teachers College in January 1955 and went on to become an outstanding elementary teacher. Her expertise was recognized by Dr. Benjamin Willis, Superintendent, when he released her from her schoolroom for five months to teach teachers on WGN TV each week. Rose and Joe were a team that created harmony. It continues to this day in all of their grandchildren. Thank you Rose!

Italian-American Women's Club

PRESIDENT
Annette Stella Dixon

VICE PRESIDENT
Sister Mary Ventura

SECRETARY
Lorrie Cartolano

TREASURER
Mary Lou (Farino) Harker

MEMBERSHIP FEE: $10.00

YEARLY DUES: $25.00

The Italian American Women's Club meets monthly on the second

Tuesday of September through June at 7:00 pm at:

St. Bernadette School
9311 S. Francisco
Evergreen Park, Illinois

MISSION STATEMENT

The Italian American Women's Club is committed to promoting awareness of the accomplishments and contributions made by women of Italian descent. Members are encouraged to share their ancestry and take pride in their heritage.

PHILOSOPHY

The IAWC is a non-profit Christian organization dedicated:

1. To promote the Italian family traditions.

2. To eradicate discrimination against women of Italian descent.

3. To share our personal stories.

4. To make known the accomplishments of successful Italian-American women.

GOALS

1. To provide opportunities to dialog with women of Italian descent.

2. To provide an atmosphere that allows members to share their personal stories.

3. To enable members freedom to express pride in their heritage.

4. To study and practice conversational Italian.